Wisdom With
Understanding
is Better
Than Rubies

Lurine Karon Greenberg
Fine Arts Collection

While wandering in Arcadia

I chanced to meet myself as a young man.

He asked me if I knew

what things in life he should pursue.

I thought, then answered as best I could.

If I were young again, and you,

I would will my mind to always be free,

for truth, flourishes in freedom.

And it is the root of integrity.

The search for truth can only

thrive in unfettered serendipity.

Stay free to risk the possibilities of life.

Be free of the fear of failure,

since true failure is to be afraid to fail.

Remember "now" never happens twice,

and fate is never late.

Free yourself from the want of things,

and find happiness in nothing,

for only nothing lasts.

Life is a great question,

but no question can be answered

until it is first asked.

That is your task, to free your curiosity

and ask of me impossible questions,

whose answers can be seen

in the twilight of my imagination's dreams,

where I invent the meaning of everything.

DUANE MICHALS

QUESTIONS *without answers*

Twin Palms Publishers 2002

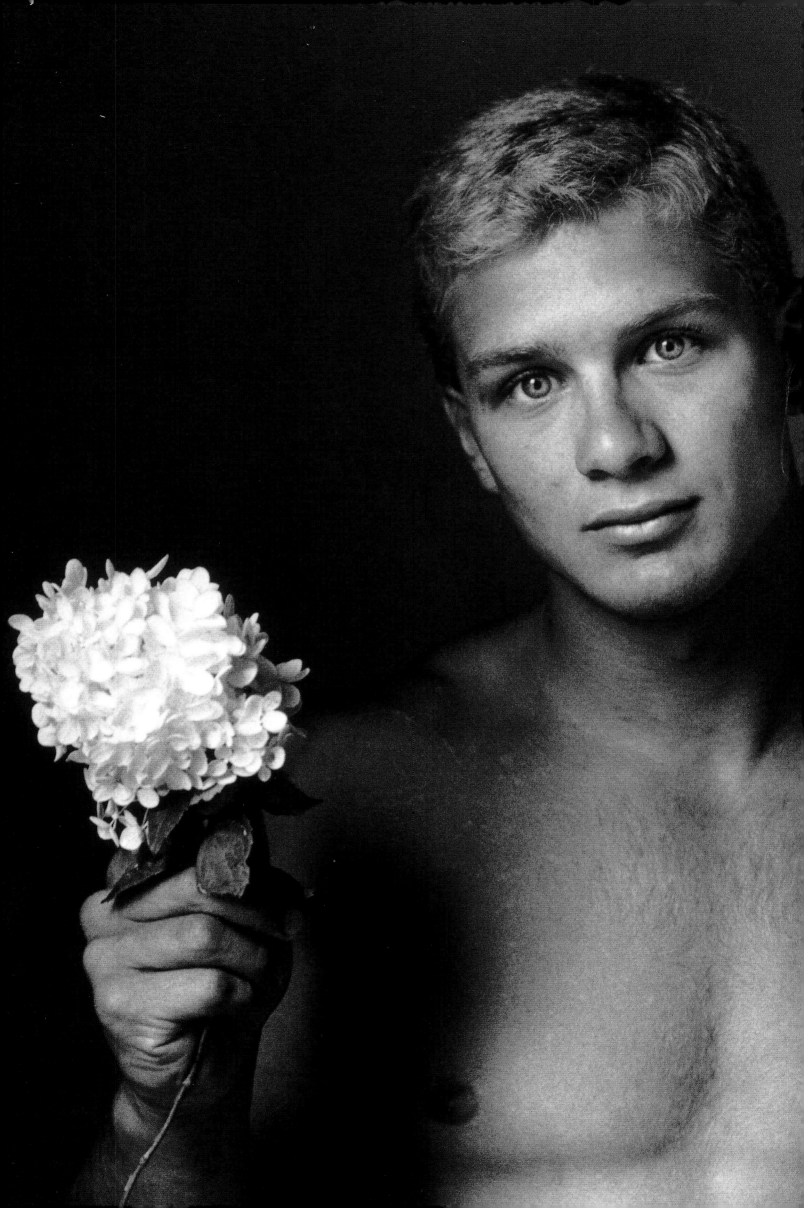

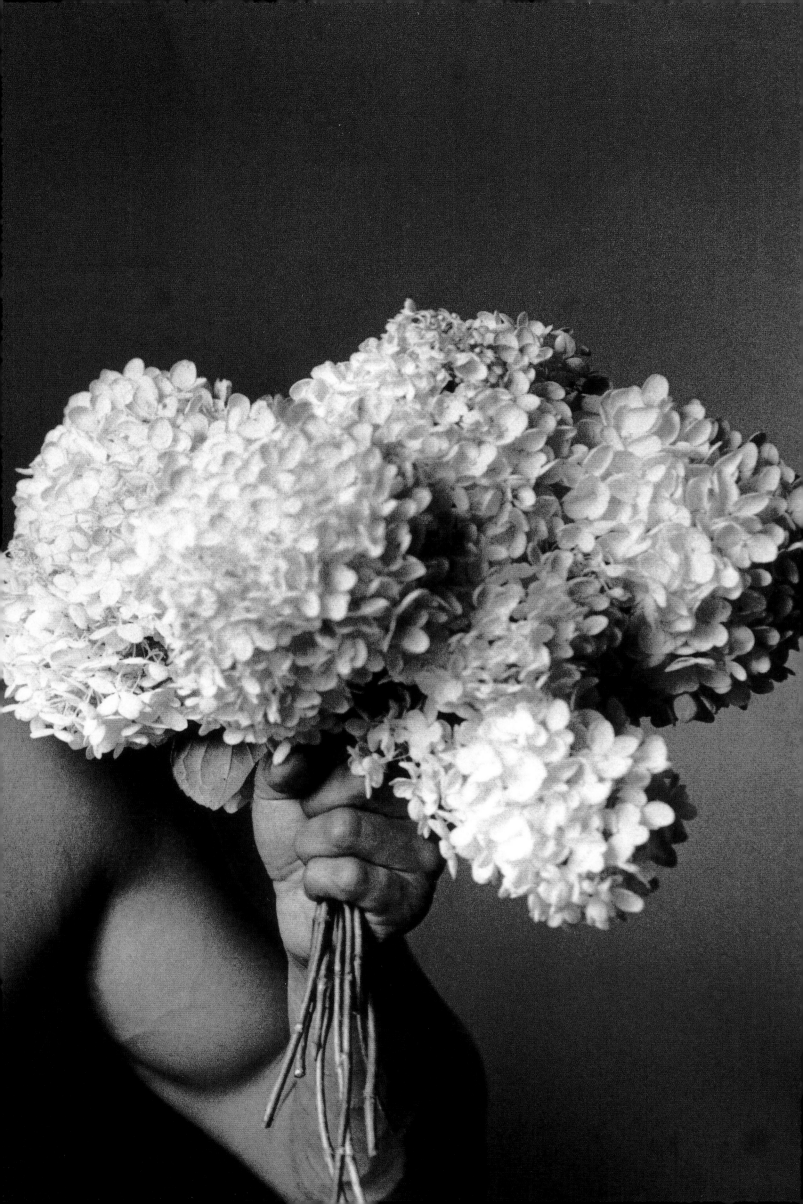

Beauty is that which is splendid and invokes in us an echo of its splendor.
It is a tenderness whose grace flowers in our glance as in a symbiotic dance.
Beauty has no goal and our role is to be enchanted by its presence.

Enchantment is a spell and we can never see through its opalescent veil.
We touch its surface with our eyes the way a blind man touches braille.

Some succumb to beauty's charm and become obsessed
though it can never be possessed,
and filters through our finger's grasp like fog.

In a flowered landscape it is a mirage of perfection
that cannot be measured upon dissection.
In the encyclopedia of human pleasures
beauty is our most noble treasure.

WHAT IS BEAUTY

The gods sent man the knowledge of beauty
to placate their guilt for giving him such a tragic fate.

Beauty most sublime is invisible, and an idea,
a fleeting gesture slight as moonlight, a principle of order,
a whim of wonder like a beatitude of kindness,
a reverie from the plight of poverty,
a secret sign, a harmony.

We are beautiful because we are its reflection.

Of all the myths that sustain our lives
the most benevolent is the gift of beauty.

Beauty asked me, "Where is beauty?"
And I in candor did reply,
"Oh my dear, it is no nearer than the color of your eyes!"

The universe is a solid emptiness, a bizarre event,
an issuance of energy witnessed as colossal globes of constellations
floating in a sea of swelling space in such numbers and dimensions
as to dwarf our modest comprehension.
This peculiar enterprise which defies the logic of our eyes
is a Chinese box of concentric worlds each inside of one another
that extends in all directions ad infinitum.

This swirling spectacle fills our night skies with stars like strings of pearls
and has its center everywhere in this strange conundrum.
This cabinet of curiosities expands in some exotic vacuum void
where alchemists' tricks are employed.
How else to explain why all the light of refracted prisms
is detained in black hole prisons.
And what of missing matter's weight, and the fate of red giant stars
those enormous bloated monstrosities?

WHAT IS THE UNIVERSE

Perhaps the Hindu myths are true.
Surging like an exhalation from the silent bindu,
that point of potentiality in repose, the cosmic order unfolds to actuality,
then deflates upon itself, an inhalation to a close.
Reason retreats from such astounding feats
and man's conceits are humbled.

The cosmos is our home and will always be unknown to us
lost children of the universe exiled in this garden of Eden, earth. ·

Lost Among the Stars

Those giant spinning wheels in space,
spinning stars like spider's lace,
will they miss my upturned face,
when my soul has left this place?

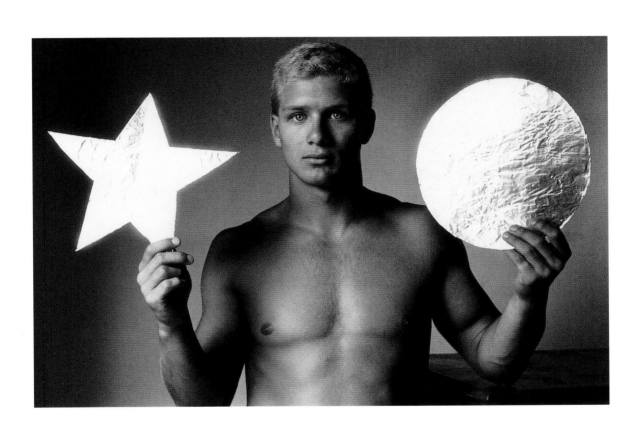

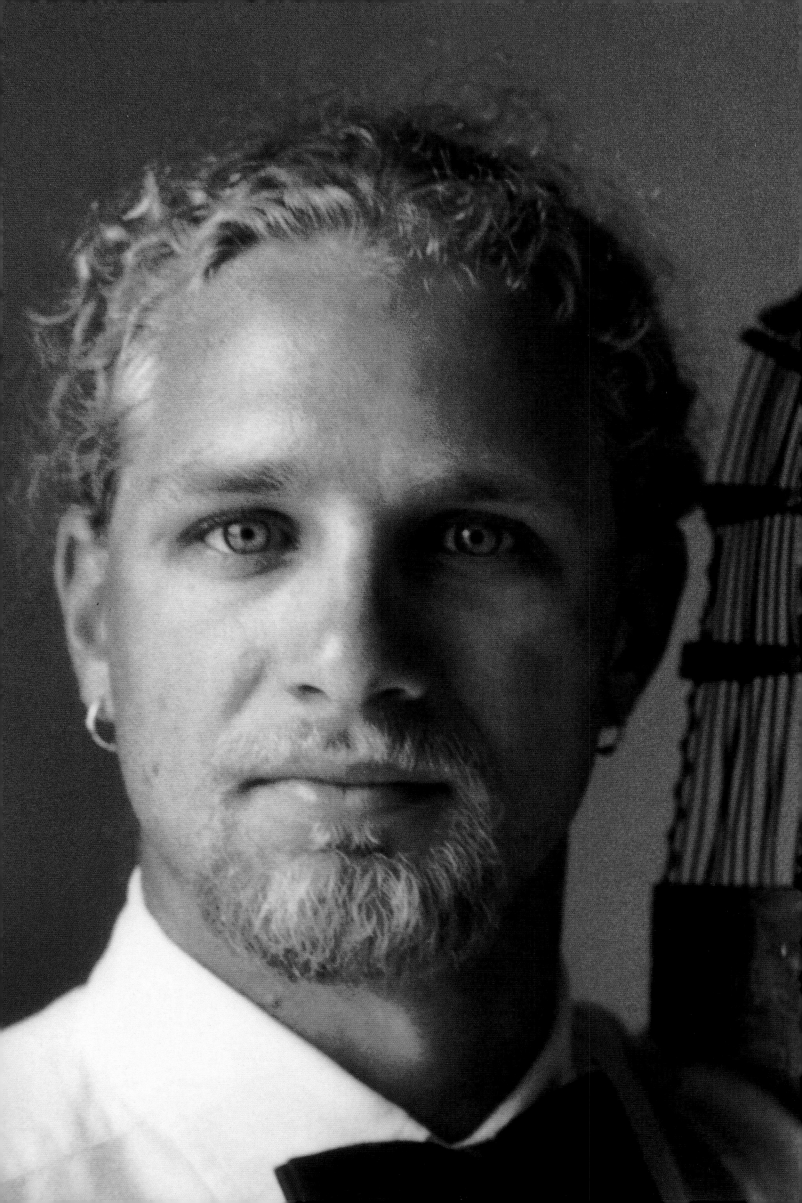

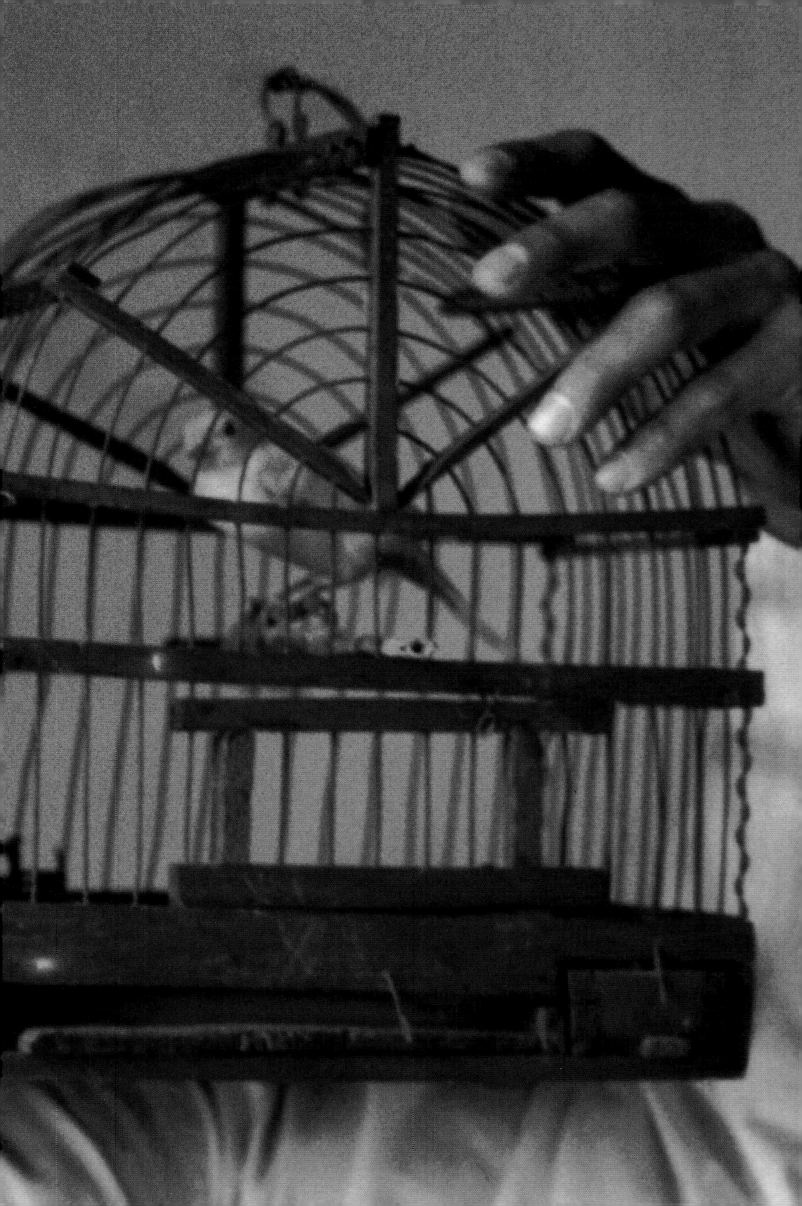

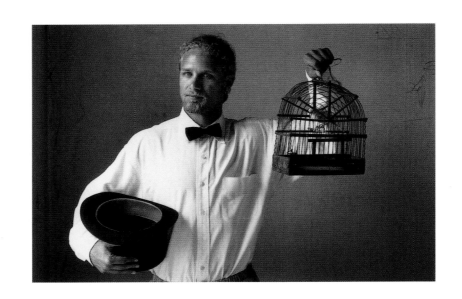

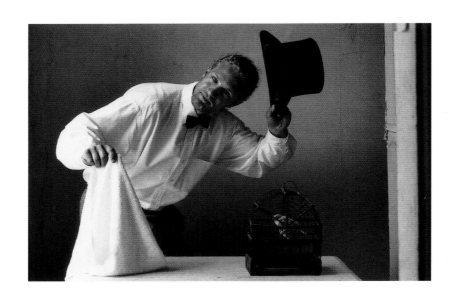

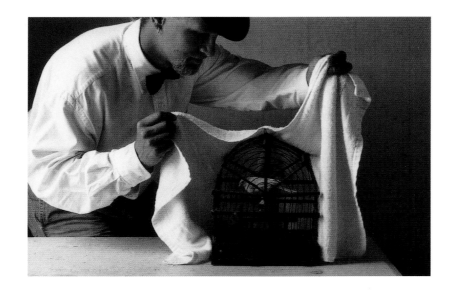

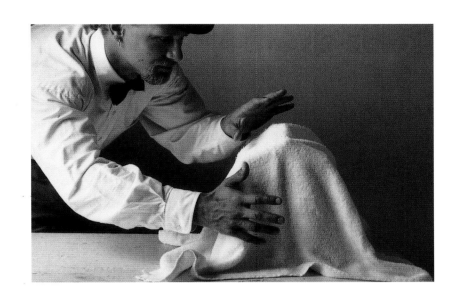

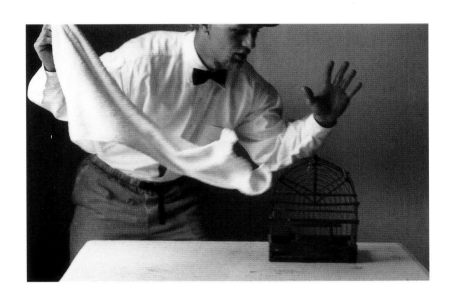

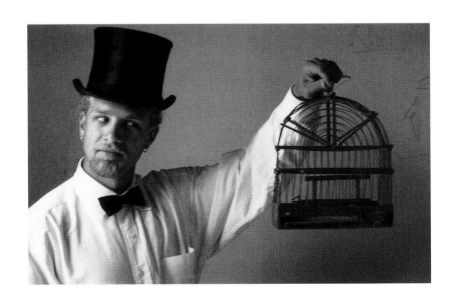

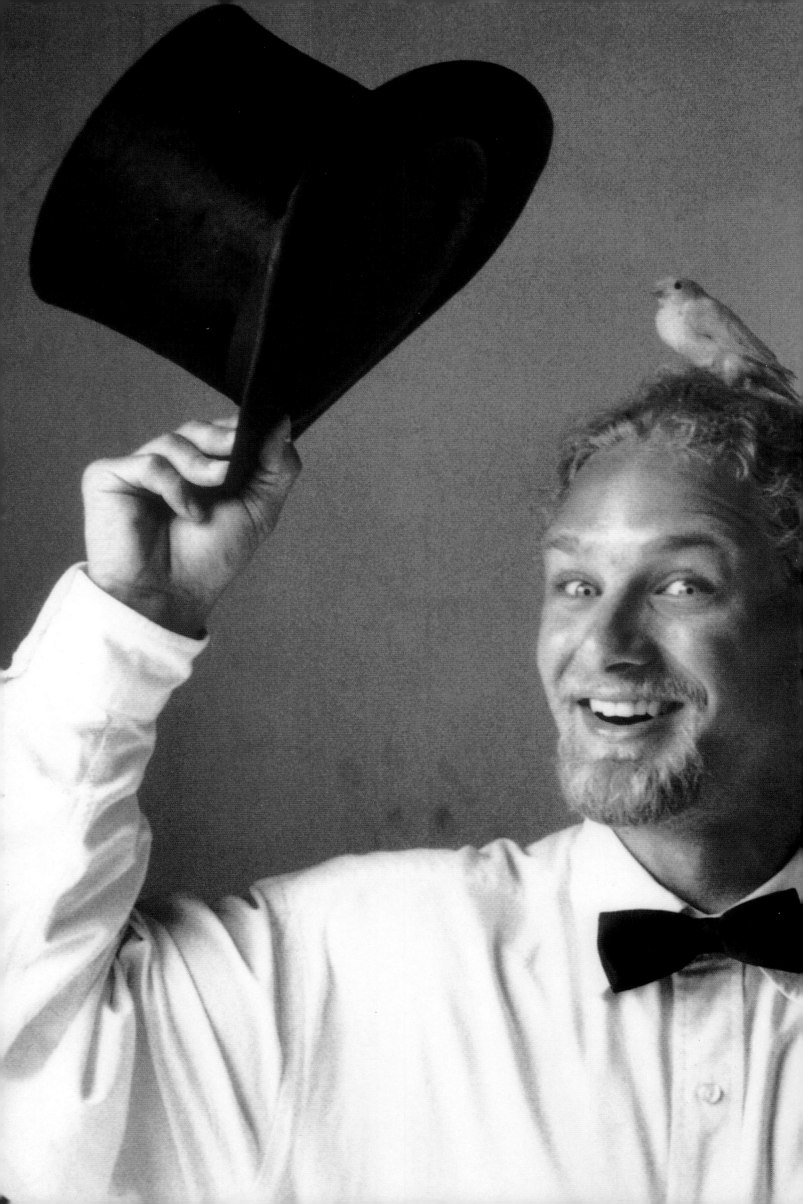

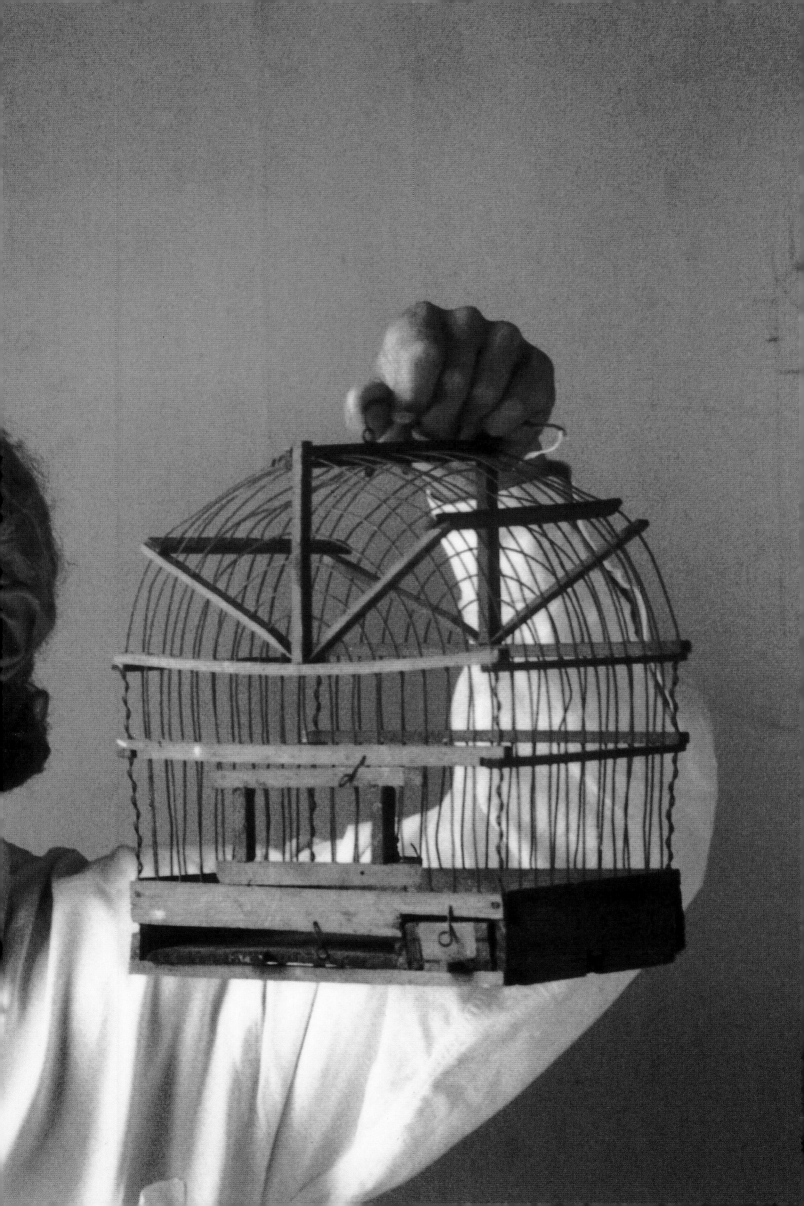

Magic is the illusion

WHAT IS MAGIC

that something impossible has happened.

Trust is having faith

WHAT IS TRUST

in another person's integrity.

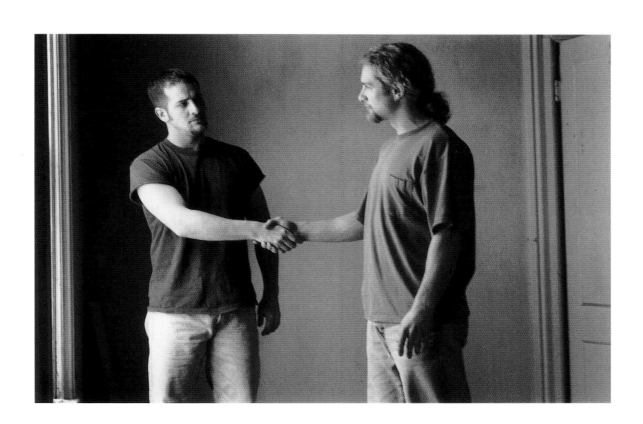

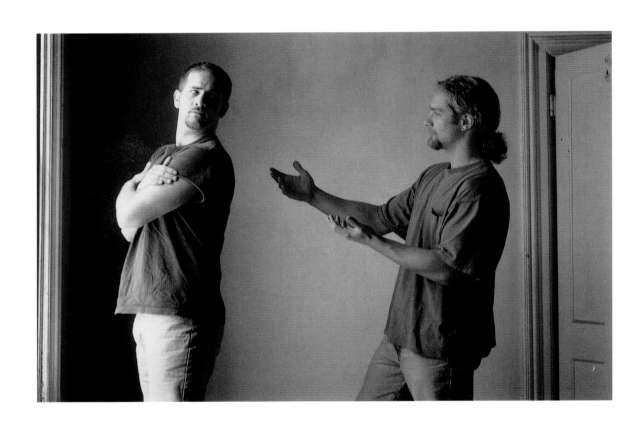

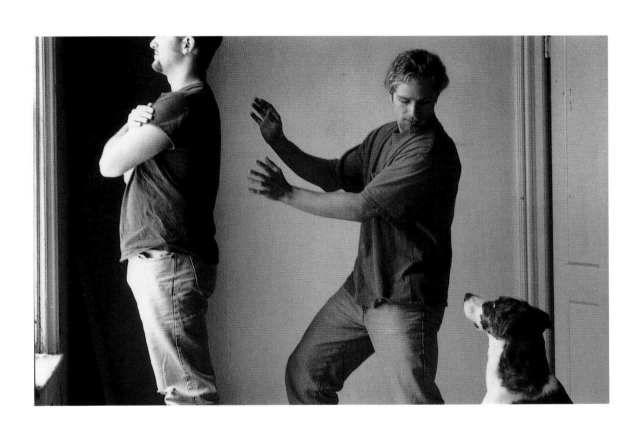

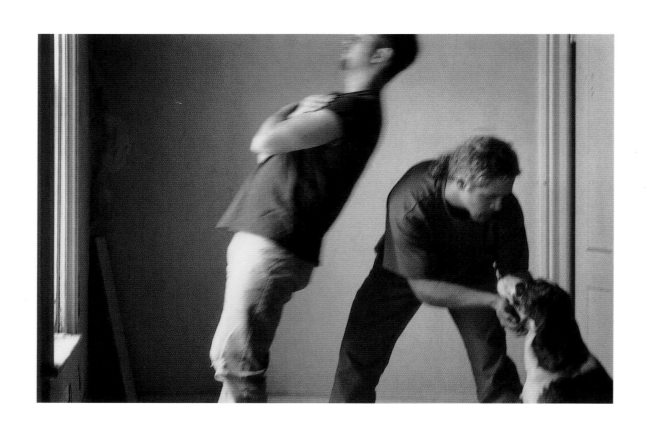

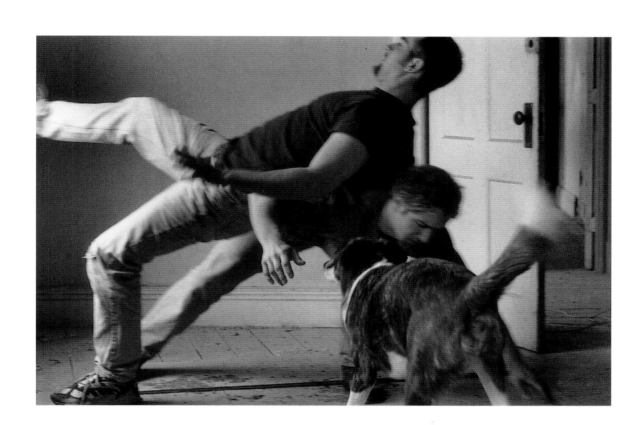

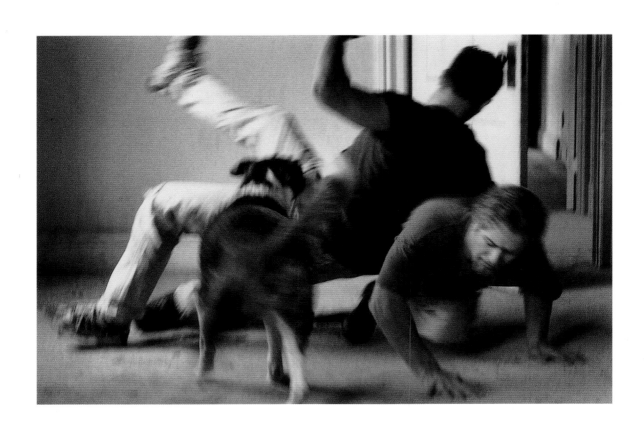

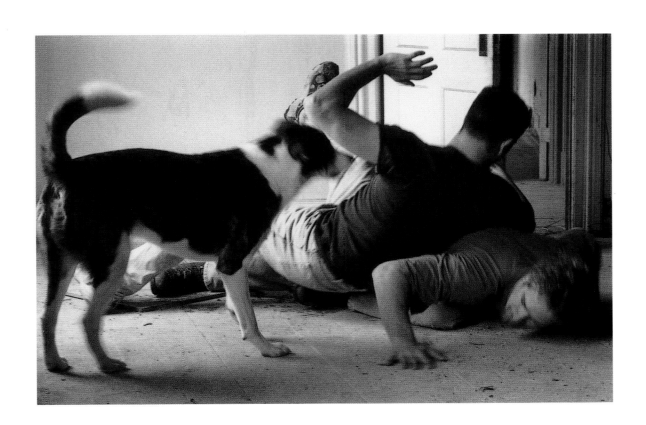

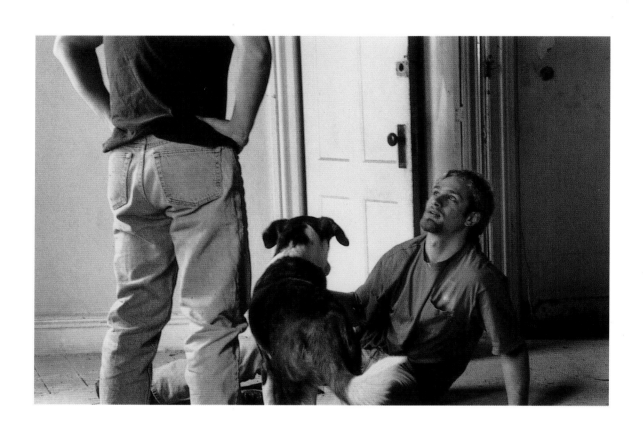

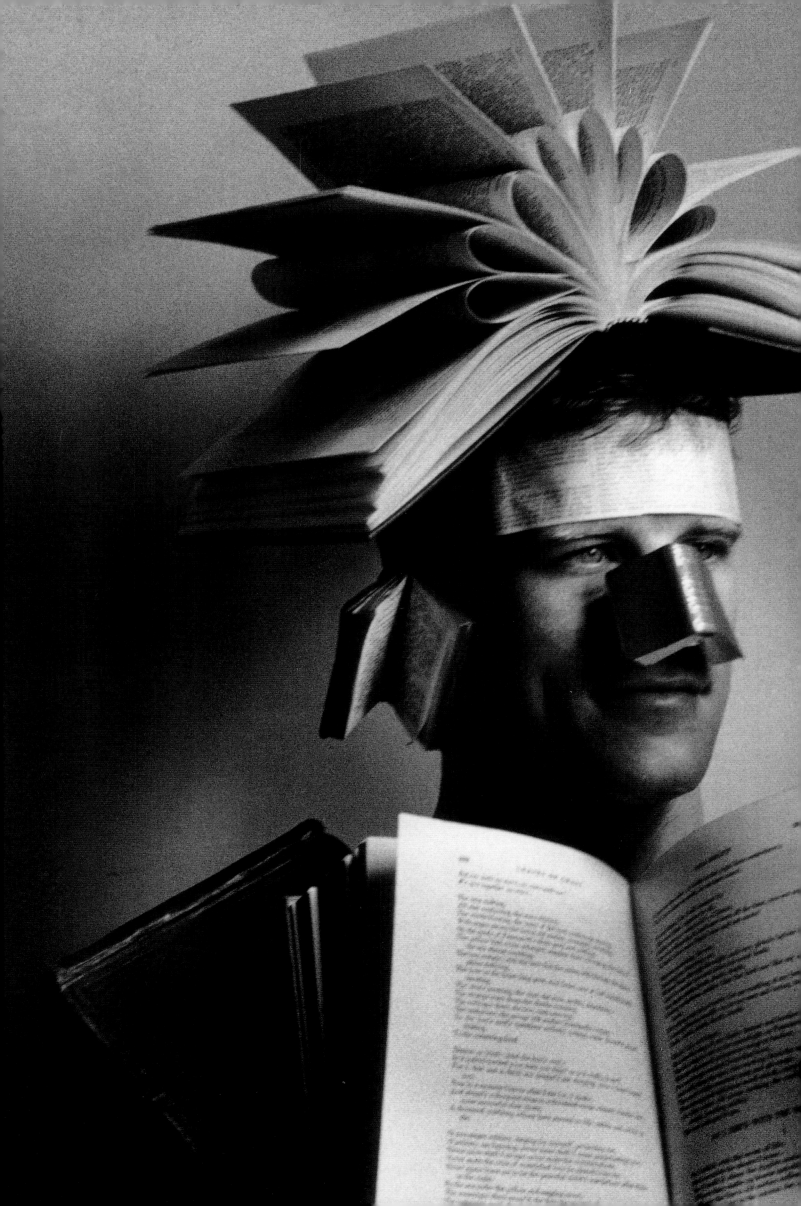

Language is the sound we make to communicate.
It is a fabric of metaphor, symbols, and ciphered hieroglyph
that thread us together with their ambiguity and miscellaneous rhetoric.

It is only noise without the meaning we invest.
Scent, cent, and sent all sound the same, but their meanings
remain altogether different. The texture of touch is true sensation.
The word "touch" is the vibration of our vocal cords creating sound.

Grammar and vocabulary are the foundation of language's tower of Babel.

Arguments are a verbal maze and labyrinth that we invent
to defend our cant. Logic dies in ranting.
The innocent should be aware that deceitful language can ensnare.

"Vote for God and me and family! Would I lie to you?"

WHAT IS LANGUAGE

Language withers when trivialized. "I love pizza and your eyes."
How many thoughts are misconstrued by the way some words are used.
"I really do love you." She thinks they're to be wed.
He thinks they're off to bed.
We hear what we want to hear and not what's said.

Children's early noises are searching sounds
creating language's playful din, half song and cry,
before labels are applied. Kiddies play with words
like toys, listen to those shouting boys.

Some things cannot be expressed.
Words fail in hollow utterance.

Sometimes it's best things not be said.
The deepest feelings can only be heard
in silence.

WHAT IS LUCK

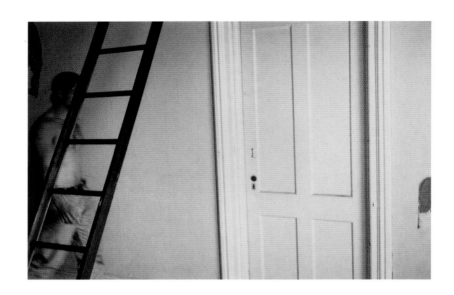

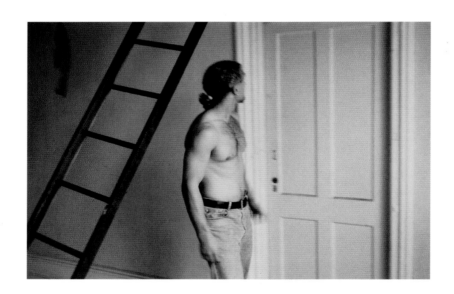

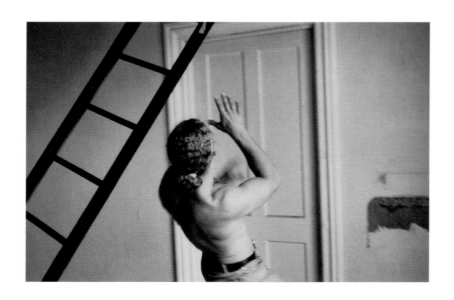

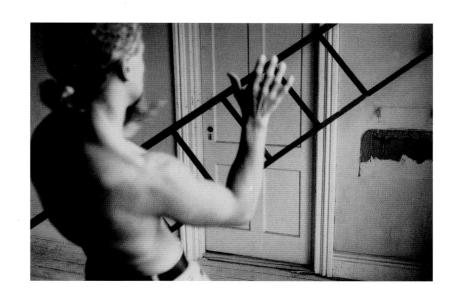

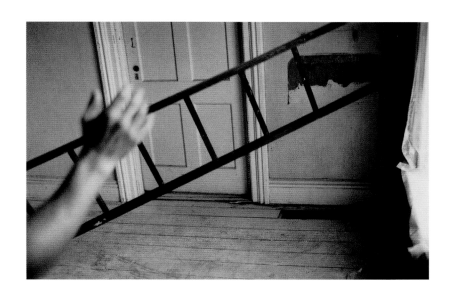

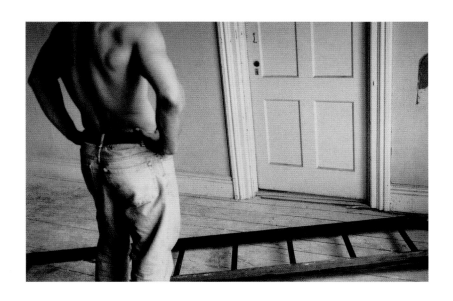

Good Luck is the serendipitous encounter of good fortune.

Bad luck is the chance encounter of misfortune.

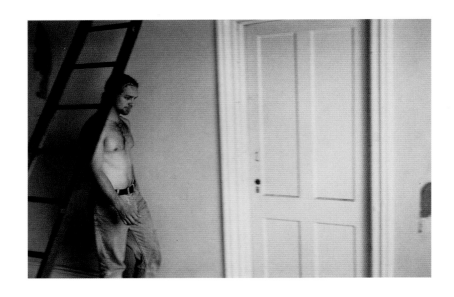

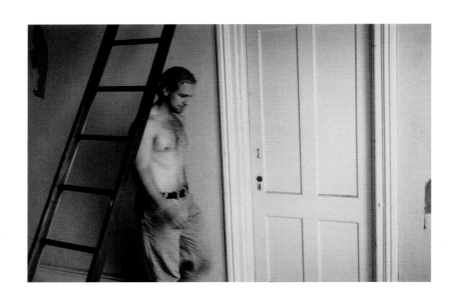

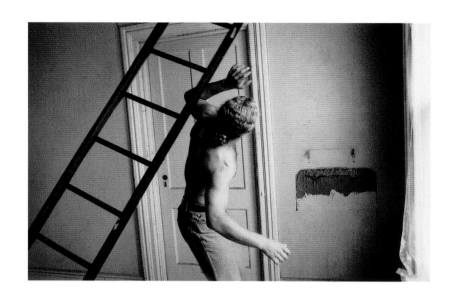

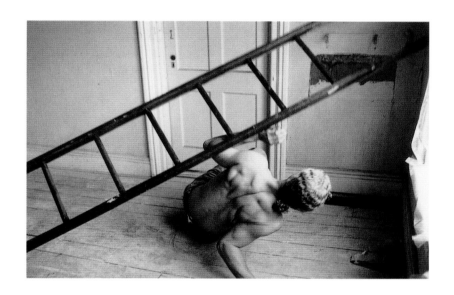

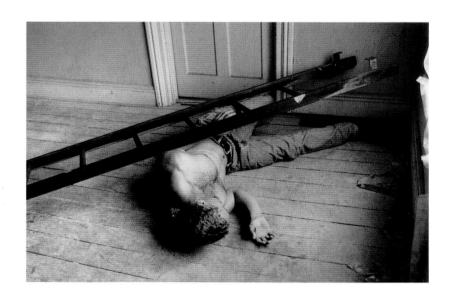

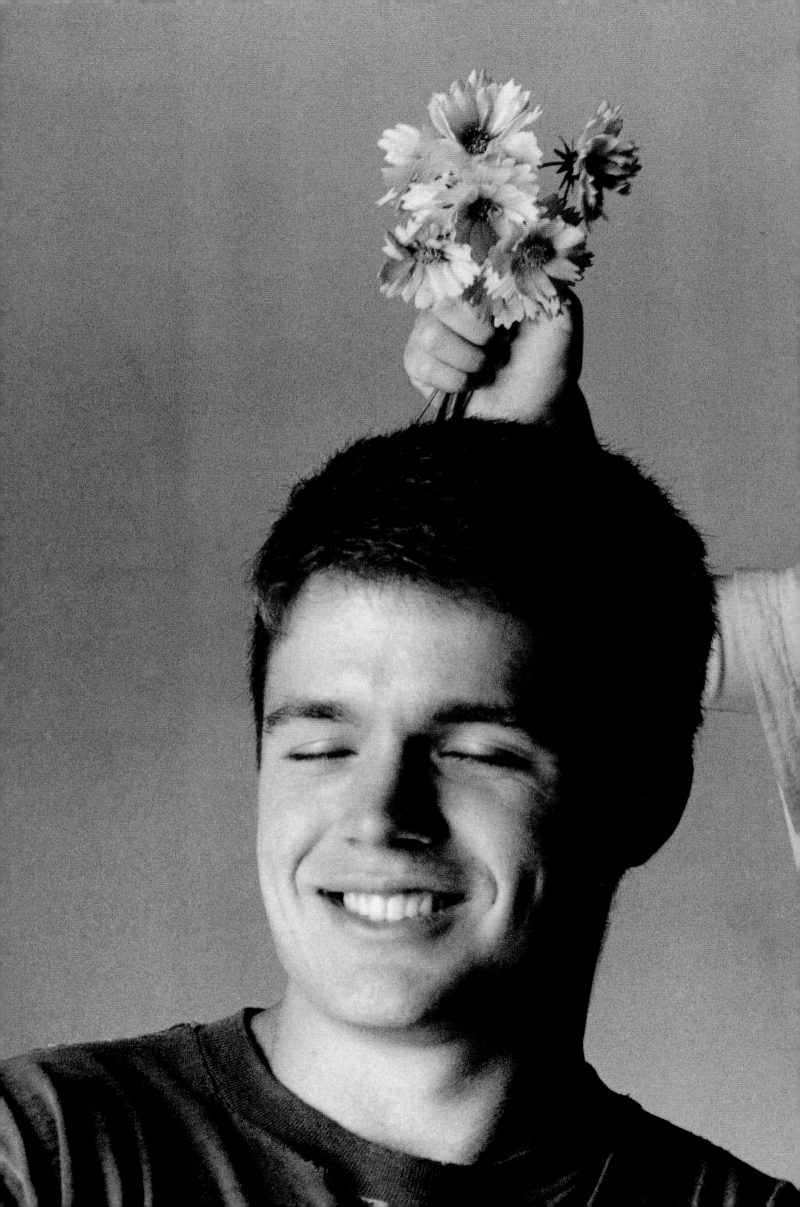

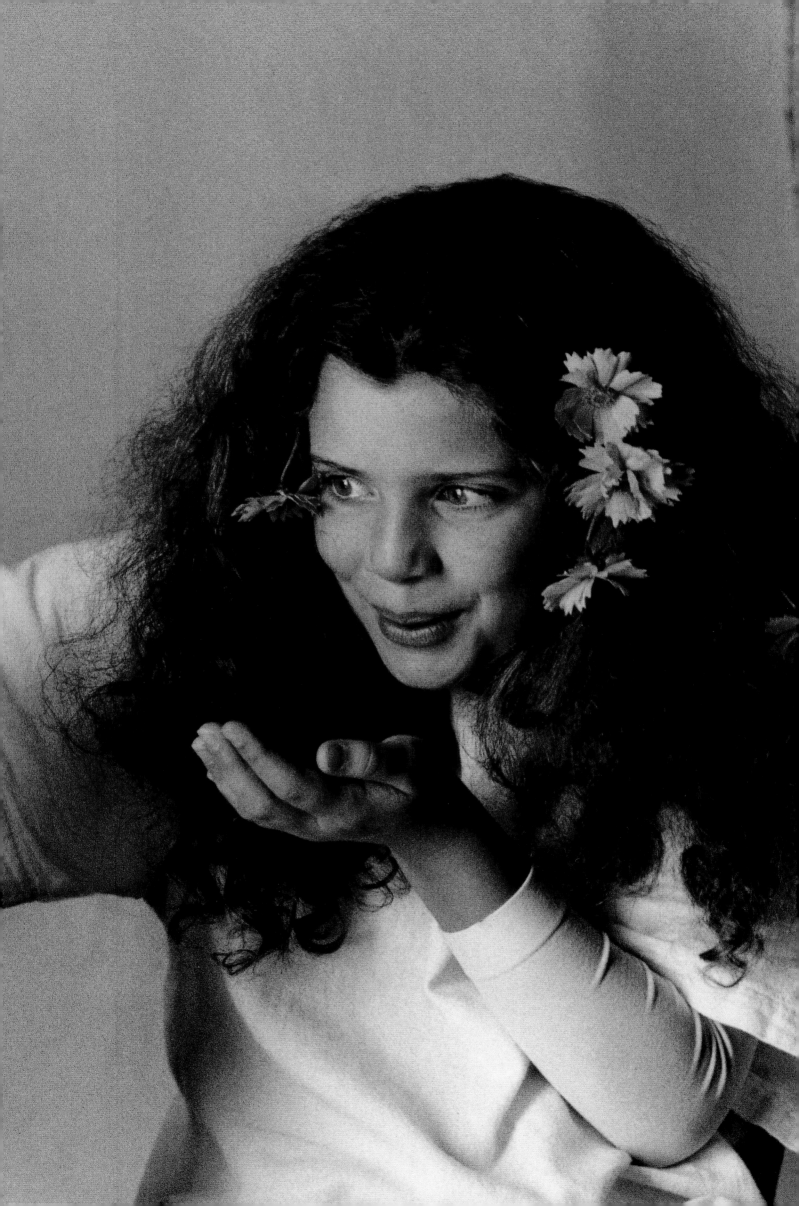

Happiness is the heart at play,
a revel of the spirit, a crocus on a winter's day.
It is a spell of lyric joy that lifts the veil of discontent
and reveals a hint of how life in heaven will be spent.
Then buoys us like a luminous summer cloud above a frozen plain,
a relief from the dismal mundane.

The self implodes in a fragile flurry of delight.
Happiness cannot be disguised. It twinkles in the eyes
and rises like the sun to shine on everyone.

How high young hopes for happiness, but few are realized.
Some live their lives as silhouettes in shadowed pantomime.
We cannot find happiness. It must discover us.

WHAT IS HAPPINESS

Unhappiness envys happiness for all the *joie* it brings.
It can never hear the music that makes happy people sing.
Fickle happiness found another friend and left me forlorn.
I played myself the double fool for I had been forewarned.

The ancients were all melancholy and distressed
until that shining hour when Terpsichore discovered happiness.
While twirling in a Dervish spree, she suddenly became
a joyous presence like a sensation of effervescence.
And this grand elation she called happiness,
because it rhymed with "I am blessed."
Terpsichore then cast this euphoria into the air
upon a breeze for all to share.
And this wandering wind was then dispersed
everywhere around the earth.

But how could Terpsichore have been aware that
man can never catch this joyful air.
Happiness for them like virtue is most rare.

Pleasure is the sensation of the saturated harmony
of our senses in full delight. The young man tastes the peach
and with each bite his mouth floods with the flavor of a bouquet of nectar
scented sweets, a summer morsel treat, a delicious juicy rondelet.

The senses feast best on a subtle menu.
The slightest touch is most deeply felt, the slightest whiff
of lavender remains the longest, the best tea steeps to the palest hue.
You find all pleasures dine in the mind.

The pleasures of the imagination are sometimes deeper than the fact.
The reward is in the anticipation not the act.
As our tastes evolve our satisfactions are more refined.
Random distractions blur as time now brings into focus
what youth chose to ignore,
the nuance of sensations it had overlooked before.

WHAT IS PLEASURE

Pleasure is the antidote for pain,
a brief respite from a moment's sad refrain.
Beware of pleasure's charm. The weak indulge their fancies
and harm themselves in addiction. Too much is too late.

Sensuality intoxicates and should not be underestimated
Who could resist the chance to rest on pleasure's breast.
Its enjoyment is like the comfort of a fond caress,
but then the touch is withdrawn. The hedonist takes a risk
that his pleasure might be denied.
Without it how can he survive?

Pleasure is a small kindness when measured against life's harsh realities.
Should it find you, do partake.
We'll have no pleasure at our wake.

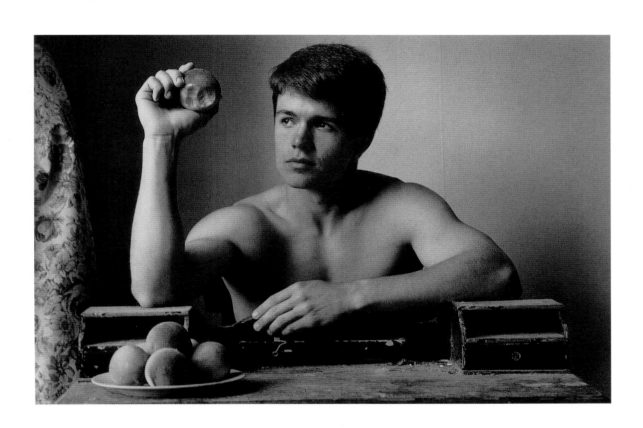

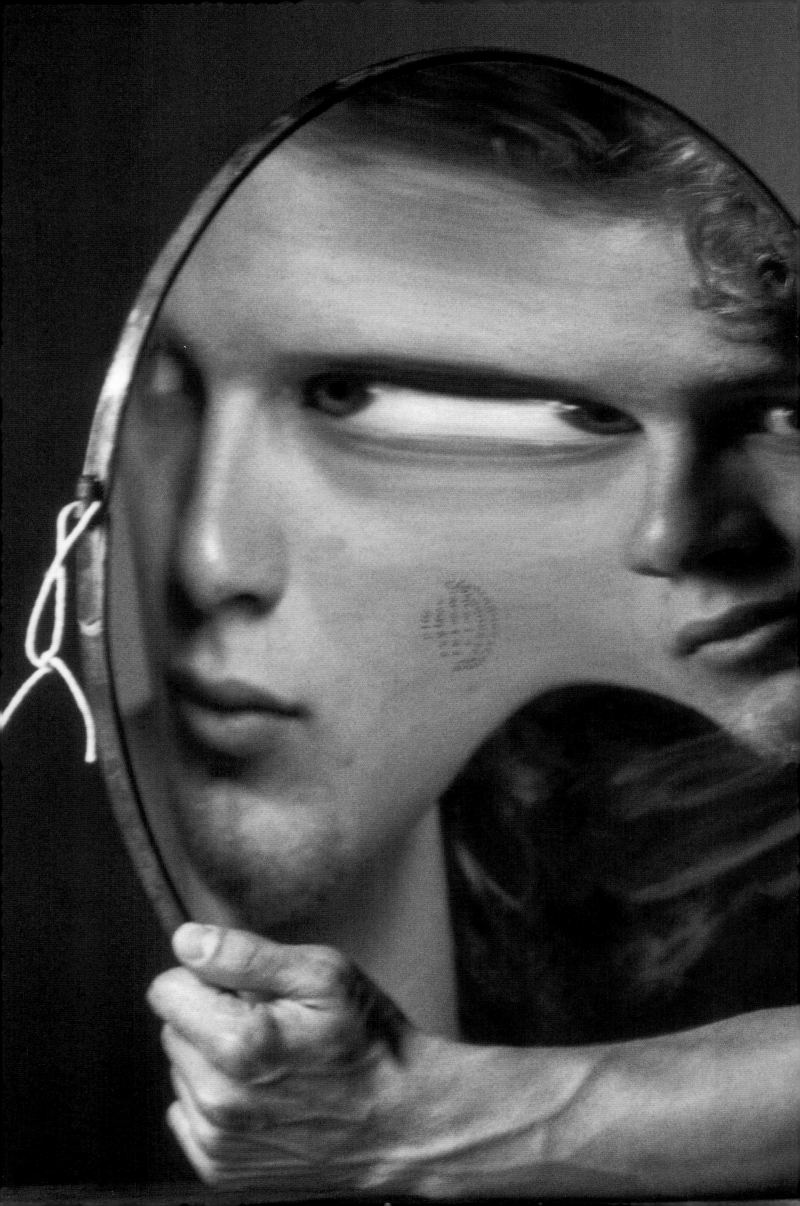

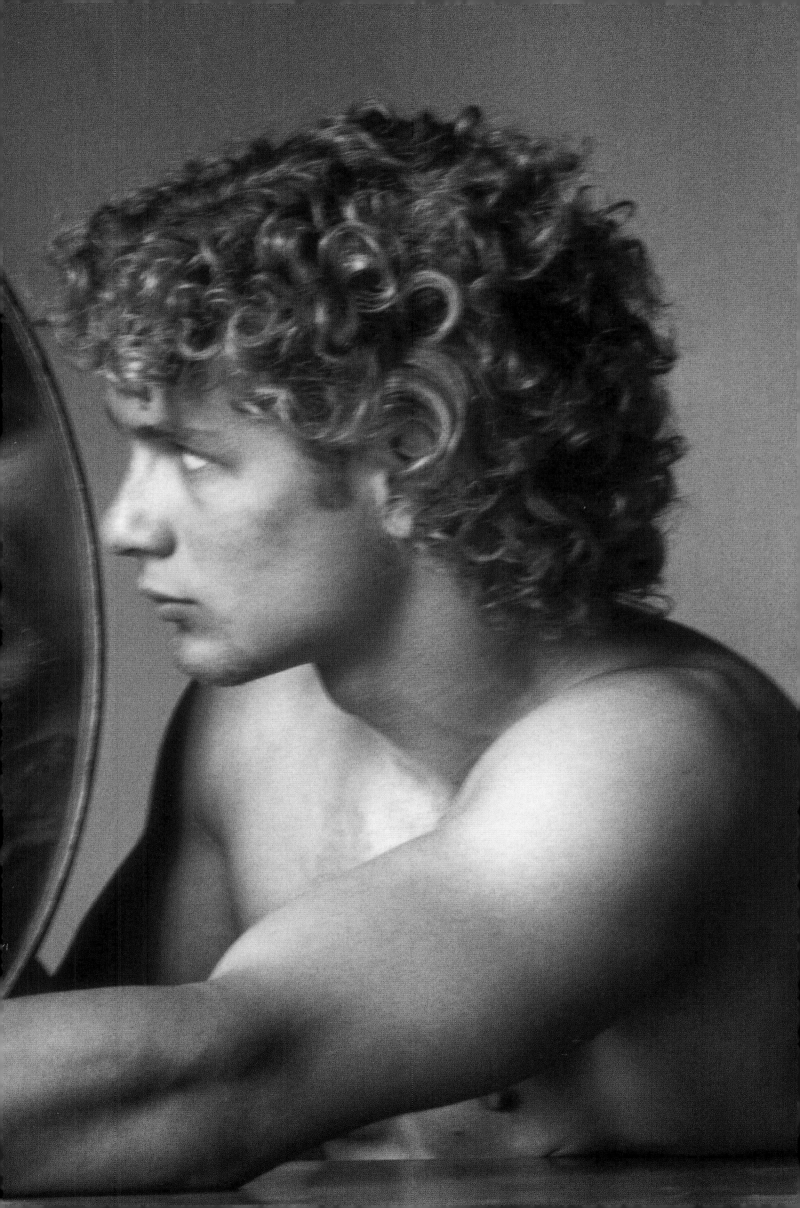

I am what is being experienced,

the universe focused in the eye of the beholder.

There is a quality of sensation felt as myself, which like the "I"

of the hurricane is a calm center of awareness.

The exact point of myself in this calm is held as if it were

in a black hole, where my purest reality cannot escape itself.

The Absolute.

I am tethered to the Absolute by the cord of consciousness.

Again and again I gaze hard at my reflection in the looking glass.

Then blink without acknowledgement

for my stare reveals no one is there.

WHO AM I

All descriptions of me are like barnacles attached to me,

for nothing is really mine. My name is a word

like any other sound, which when repeated blurs to babble.

My pride enjoys the false luxury of vanity,

a cosmetic decoration that casts me into the farthest ring of self-delusion.

I distract myself with novelties. But they are not me.

I identify with follies. But they are not me. I am an accomplice

to my own ignorance. Under the magnifying glass of attention,

my personality has the permanence of fog.

I communicate with myself in monologue.

My questions echo in my mind.

All this thinking exhausts me and I must rest.

But who falls asleep and dreams?

WHAT IS CONSCIOUSNESS

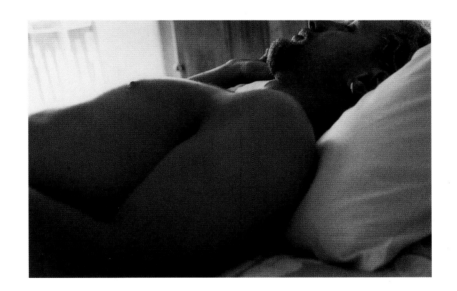

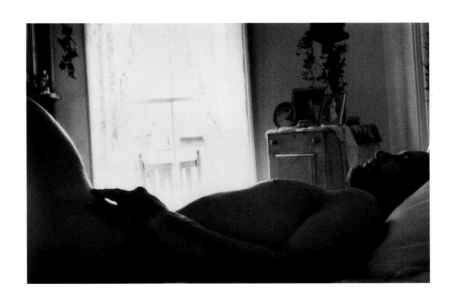

Consciousness is how we experience being.

Each night we dream in the womb of sleep and
every morning we awaken reborn
into the dream of life.

THE SEVEN AGES OF MAN

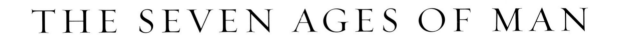

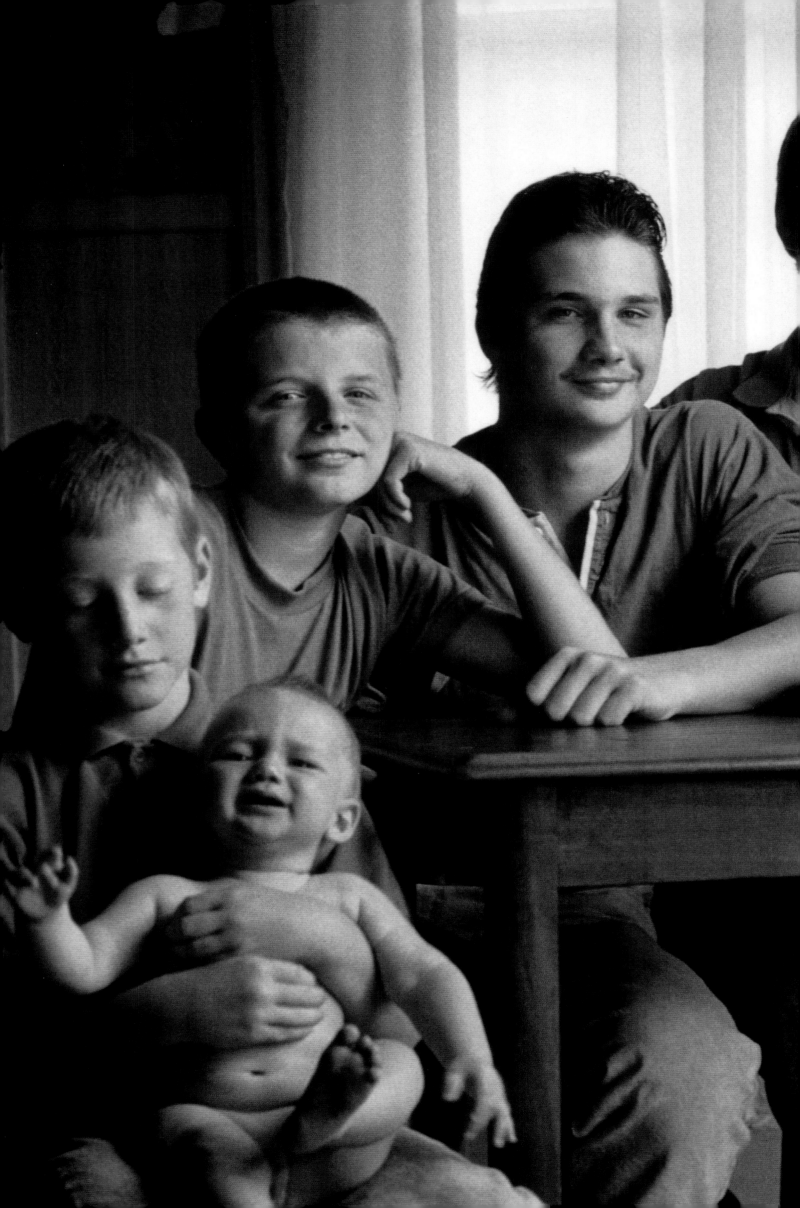

INFANCY

The dark sea journey to dawn's light,
all is pee and sucking appetite.
Everything he sees is he,
baby cries and in his sleep he dreams
of falling from the sky.
Now hush, hush and lullaby

CHILDHOOD

First the grasp, then crawl to walk
and talk then run to school and fun.
The world's a room and mom and dad
are sun and moon.
Children are the last to speak
the twittering sign language of songbirds'
squawk, and know the words of fairy tunes
that they'll forget so very soon.

ADOLESCENCE

The sprouting shoot hardens
and extends a fuzzy chin,
the telltale signs the boy is
ripening on the vine.
The awkward right-angled days begin,
his childhood days were foolish whims.

YOUTH

The peak of promise has arrived.
This is the fair and lovely season,
before time and age commit their treasons,
and burrow furrows in the brow.
Danny is now called Dan.
This is the year manhood began.
He is a warrior now.

MATURITY

It is the center of his life
He's been to war and wed a wife.
He has a kid or maybe two,
and does the work his father did.
He didn't know what else to do.
His days have now become a habit.
He is no more the randy rabbit.
The warrior has now become a worrier.

MIDDLE AGE

So this is who he came to be.
Perhaps he should have gone to sea.
It's true he never was the best
and doesn't talk much to his wife.
But it's more or less the life he chose.
He's more or less content.
Perhaps he should have gone to sea.
It's all irrelevant.

OLD AGE

Pain denies that pleasure
which once was,
and cheats life of all its meaning.
His dear wife has gone ahead.
Old men sleep alone in bed.
How quickly it all came down to this,
A sigh goodbye,
and the memory of a kiss.

The sphinx waits eternally to reveal the secret of the great mystery
to those who would ask. But alas, we, who live perpetually in the shadow
of the eclipse and who have never seen light, or been blinded by the sun,
do not know what questions to ask.

Therefore consider that all is mystery
and our reality is one of its disguises.

WHAT IS THE MYSTERY OF THE SPHINX

Think of our brief biographies as evidence of this enigma.

Does consciousness have weight?

Perhaps everything possible has already happened
and our lives are a slow remembering of a long forgetting.

Now, as I say now,
a multitude of generations is being born.
a multitude of generations is dying.

Things are queer and much queerer than they appear.
The mystery is that there is no mystery.

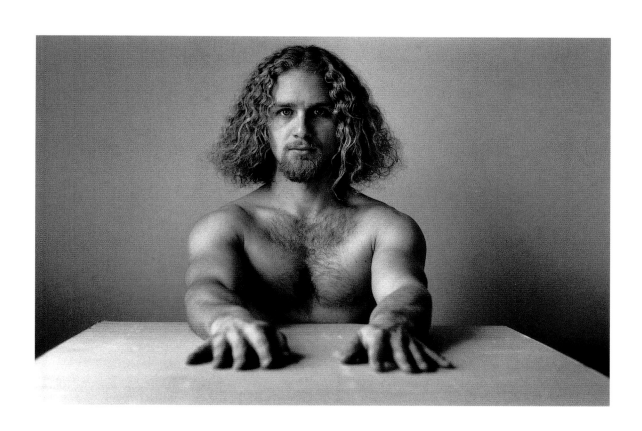

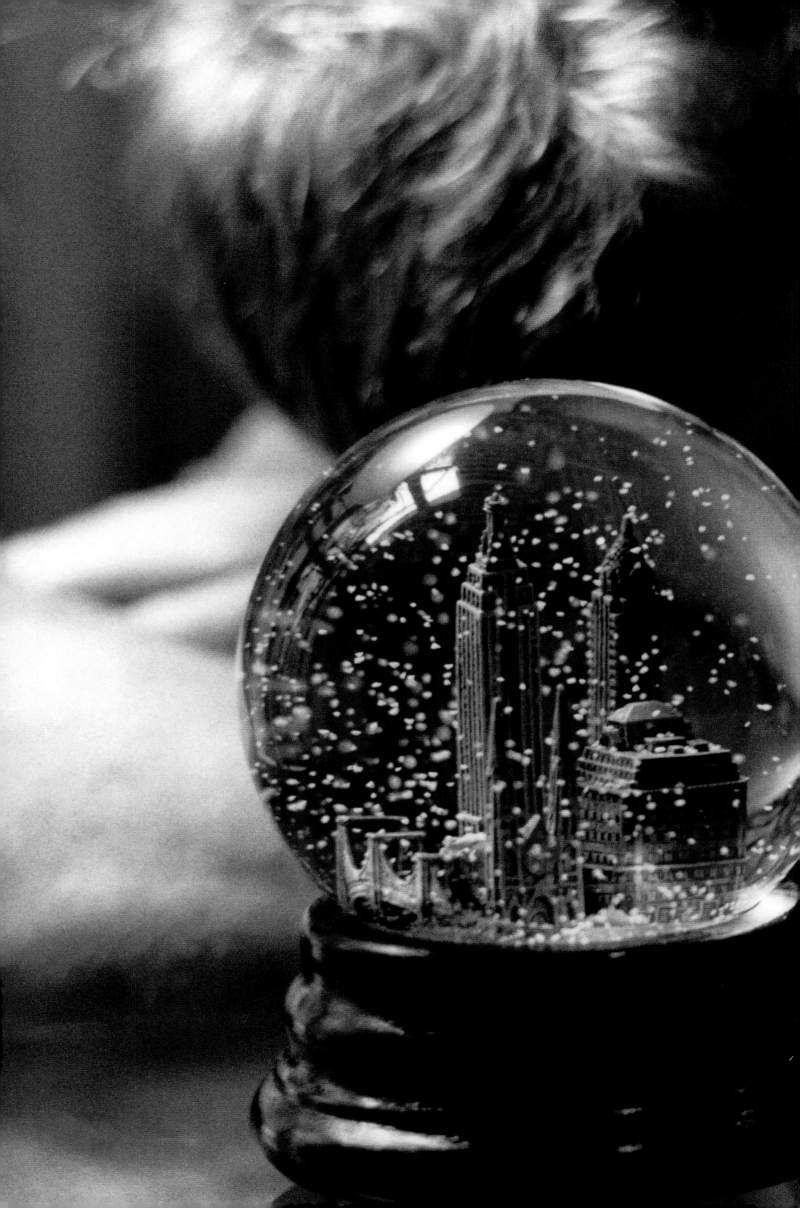

Dreams are the midnight movies of the mind,
where the sphinx recites his riddles to the blind,
and as our daydreams sleep our night dreams come awake.
Phantom visions float as we in reverie recline.

On this slumbering plain, a zephyr fans the embers of lost dreams
to flames, that pantomime their shadows on our brains,
where things look familiar, yet not at all the same.
In this chimera's hallucinations the strange become
the ordinary without surprise
and desire and terror thrive side by side.

WHAT ARE DREAMS

I wander down the Passage Vivienne, and in its window see displayed
what might have been, and I commit my sins again.
In lucid dreams the dreamer comes awake and sees that
what he thought was real was fake.

As I write I now know too,
that the universe is a great dream room,
imagined by our senses in this womb.

It is our enigmatic fate that
we must dream in time and wait.

Memory is the cemetery of our histories' spent days.
It is the prologue to this moment's scene in our lives' one-act play,
where ghosts perform their turns upon recall, and we are
the author and audience of it all.

Memory is our evidence of ever having been, where recollection lies
and often wears a mantle of disguise when viewed
through time's pale shadowed scrim. Its echoes are a dusty din.
For some their memories are more real
than what they now do touch and feel.
They rehearse again the scenes they performed
in a once happier then.

WHAT IS MEMORY

In the library of our minds, all the scenarios of our acts are found.
Among our memories' ancient props are the lists of our hits and flops.
Even memory forgets its plots
in the wisp of that haunted ground.

And when we write upon our diary's last page,
life will have been one great memory of when we once had been,
which is then forgotten as we leave the stage.

If I indulge myself in memory, it takes me to that place
long ago in Germany where I somehow still remain.
What was his name? Ah yes, Dieter, in the rain.

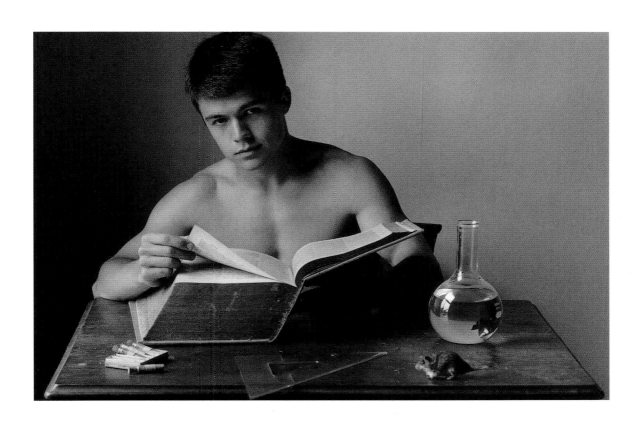

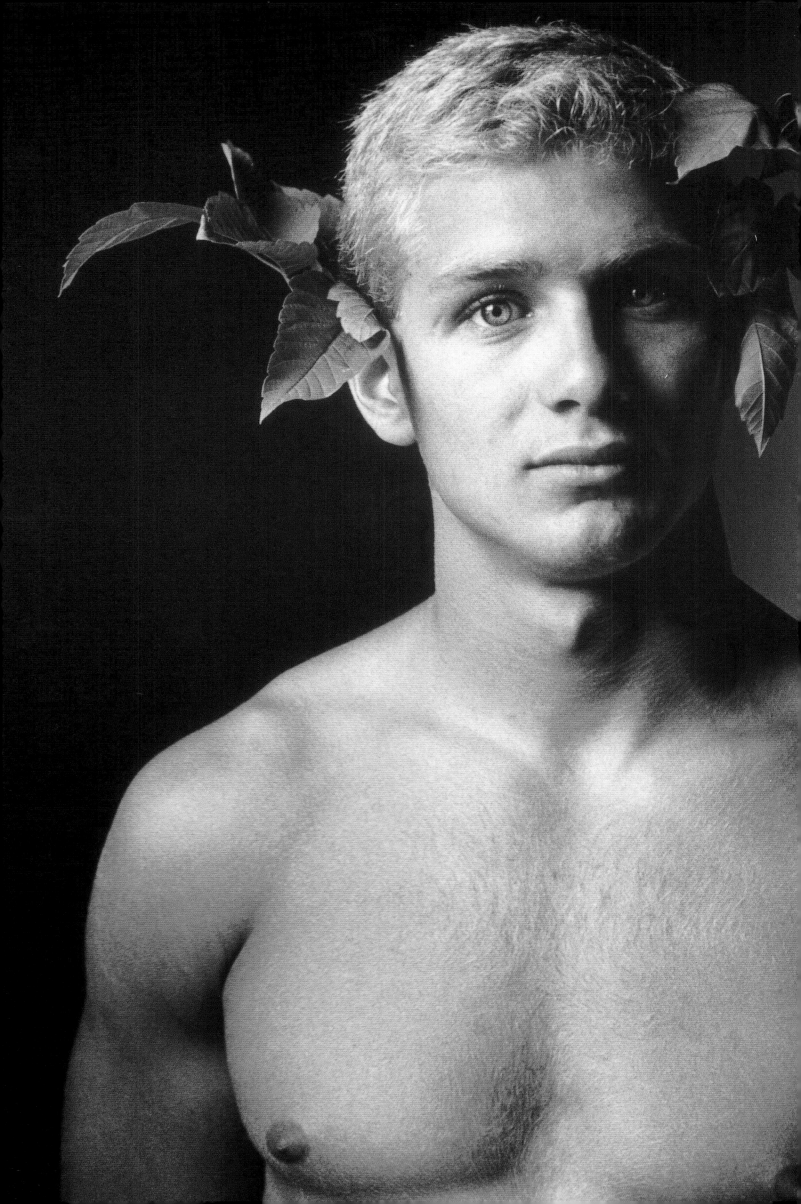

Youth is the time of salad days when he who is the boy no more
and not yet man begins to play the hero role of warrior male,
as told in all the ancient tales.

He steps across this threshold and the door of innocence is closed.
He must experience all those lessons that cannot be taught
of what he ought or ought not do and what in life is false or true.

His body's promise has been kept, it reached fruition while he slept.
When he awoke there was no sign that
then it had begun its decline.

The day when he measures himself
against his father's strength and grand accomplishments,
he puffs with possibilities.
He's passed no tests nor gone to sea; he has no laurels to be rested.

WHAT IS YOUTH

His root sprouts a solid stem that will flower in a spouse.
Reckless youth play games of risk, they have no tryst with death.
Like Icarus close to the sun, one foolish leap and they are done.
The day of reckoning had come too soon.
The clock said it was half-past noon.

Youth is a brilliant moment bathed in light,
when the fledgling climbs the crest of twigs atop his nest
and extends his wings in space.
Then with great courage and awkward grace,
he leaps into an unknown place.
In triumphant exhilaration and pounding breast,
he feels the shock and lift of flight
and soars free
to his chance of destiny,
and flies as far as he can see.

Old age is that place in time of a life lived long,
when all is past and the future's gone.

Now, a different song is sung,
and the world is viewed from a higher rung.
The soul is closer to the sun, which melts the body of its youth,
sinew, bone, and yellow tooth.

As the arc of age descends, reality is less real.
Vanity cannot protect, nor failed ambitions be concealed.
The truth has left grand dreams bereft.

So much in life has lost its worth,
the body stoops to greet the earth.
The self's geography has changed.
Lines that once were streams have been replaced
by the wrinkled rivers of the face.

WHAT IS OLD AGE

The body wakes one day in pain,
a new sensation it cannot explain.
The sturdy youth now needs a cane.
At dawn he felt death say his name.
The young man has no time to waste;
the elder does not move in haste.

Old age is a fragment of its prime,
a summer rose now in a winter's clime.
Like all events experienced, old age is by nature innocent.
We define what it will be, comic turn or tragedy.
Our audience is dead.

With the settling of the dust,
as in time all things must,
the echoes of our lives are heard.

It made no sense. It seems absurd.

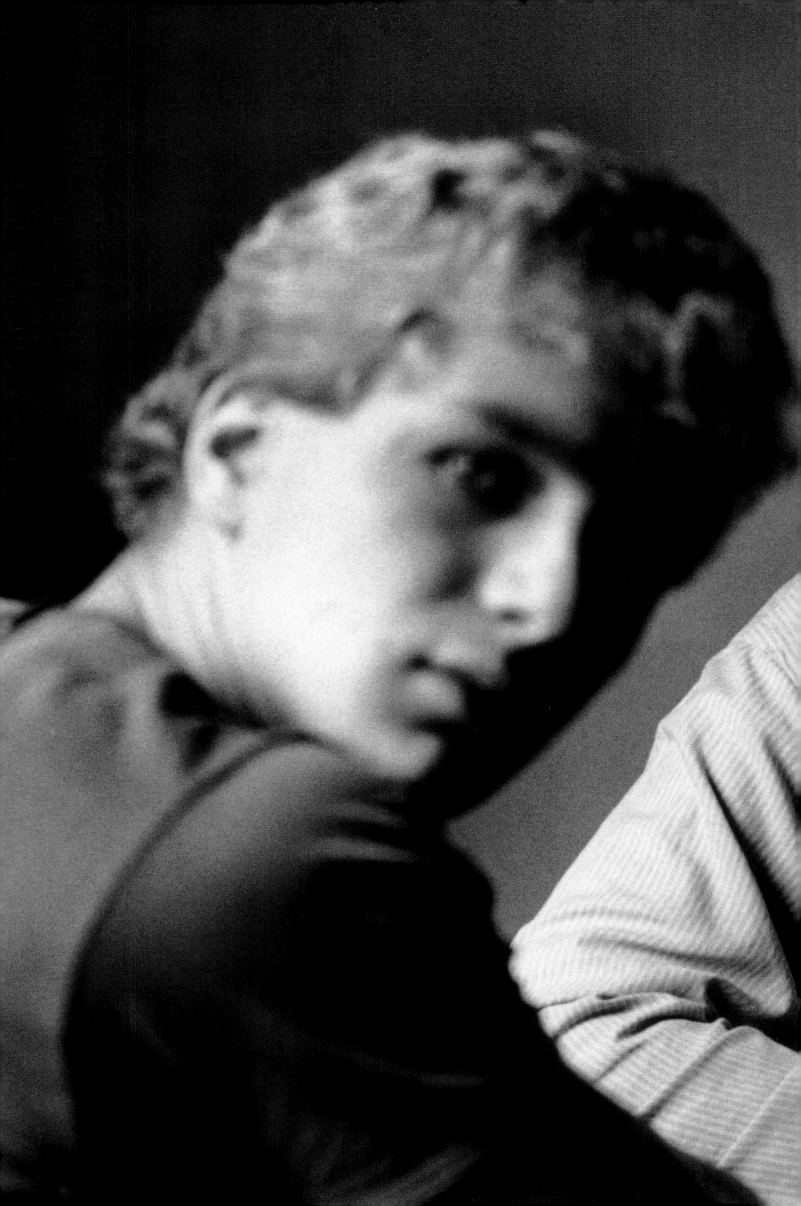

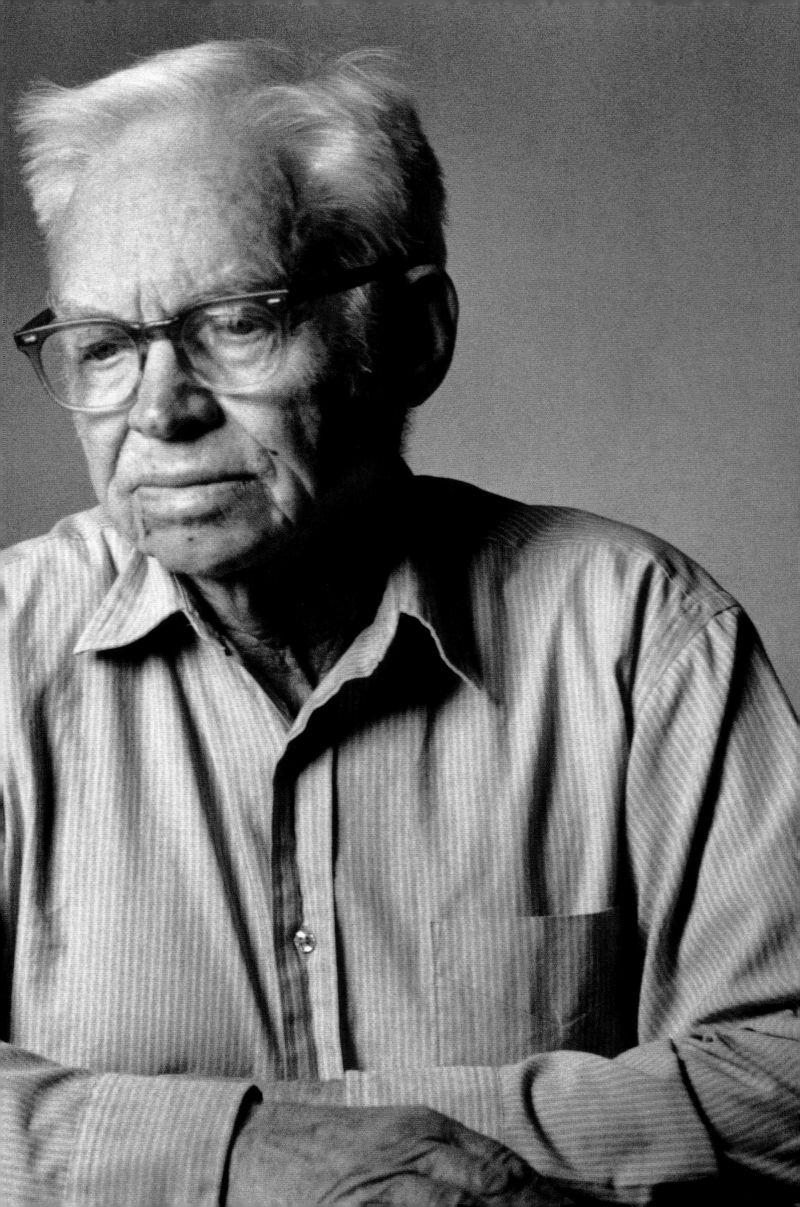

Time is the duration of everything.
Its measure is the essential dimension;
the moment is the interval between
now and then and then again.

Time is a thought, and we are the clocks
whose heart is the clock's tick and tock.
Time is vacant, and depending on where,
it is both the tortoise and the hare.
Since nothing ever happens twice,
each moment is a toss of dice.

WHAT IS TIME

Time is always now, there is no past
except what lasts in the flickering shadows of our memories' doubt.
There is no future except in the anticipation of salvation for the devout.
Now is a contradiction of fact and fiction.
Genesis erupts into a cornucopian extravagance of life.
The secret key to the arcane mystery of all things
imaginable and unimaginable is in the brevity of now,
a timeless flash in perpetual continuum.

Here language fails, and we are confined
within the mind's capacity for comprehension,
bound within our four dimensions.

Our illusions float on waves of time like concentric circles in a pond.
Time recedes from the moment's splash
and the ripples widen into waves of stillness
where time becomes nothing.

Clocks lie, there is no time.

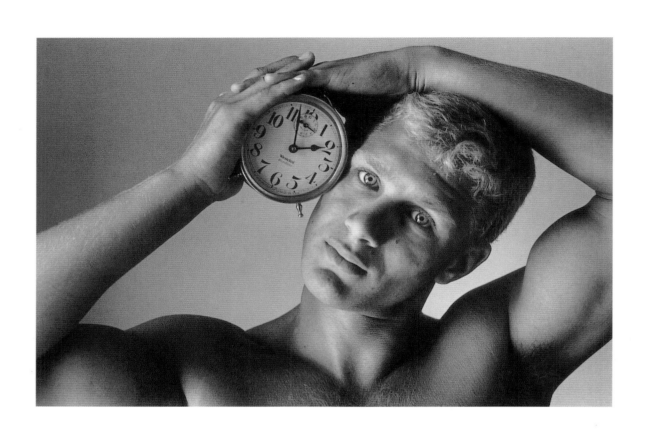

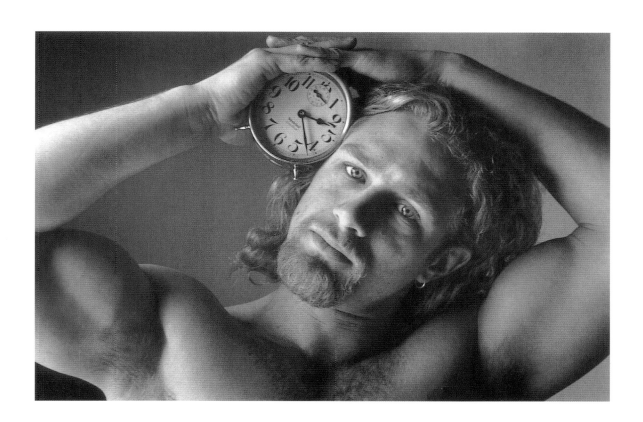

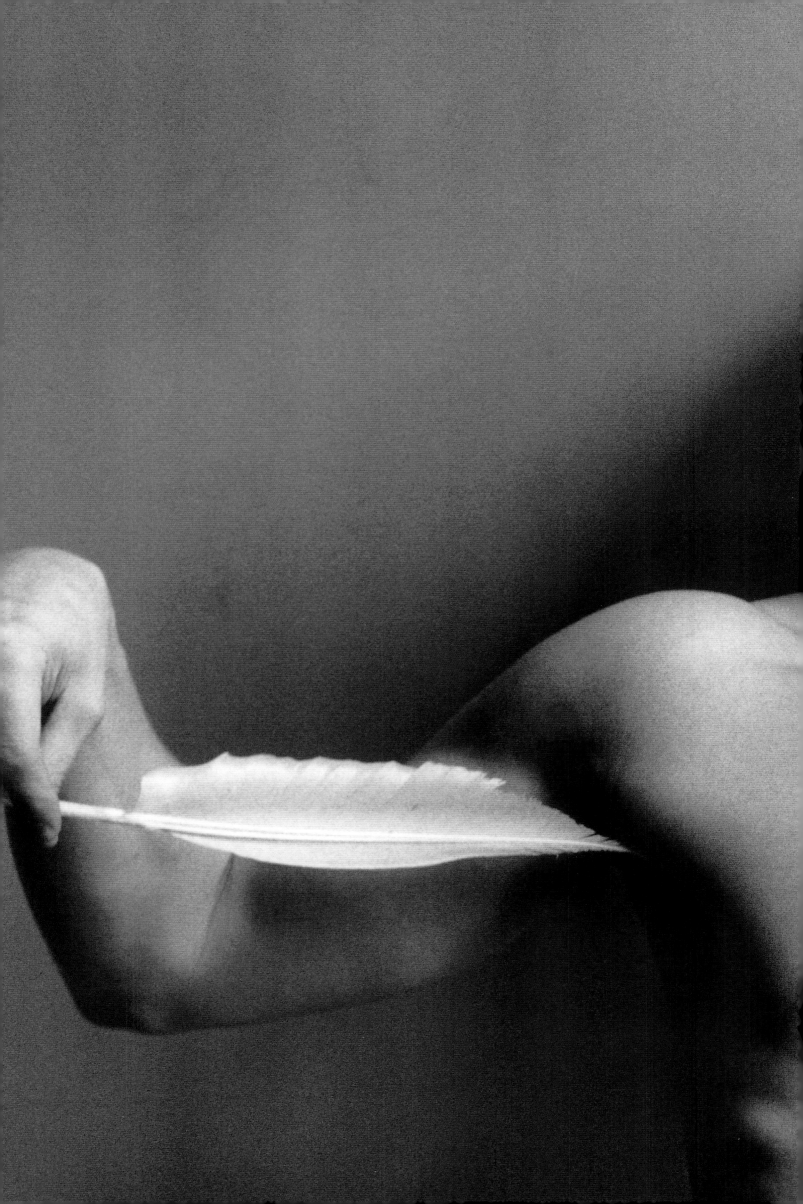

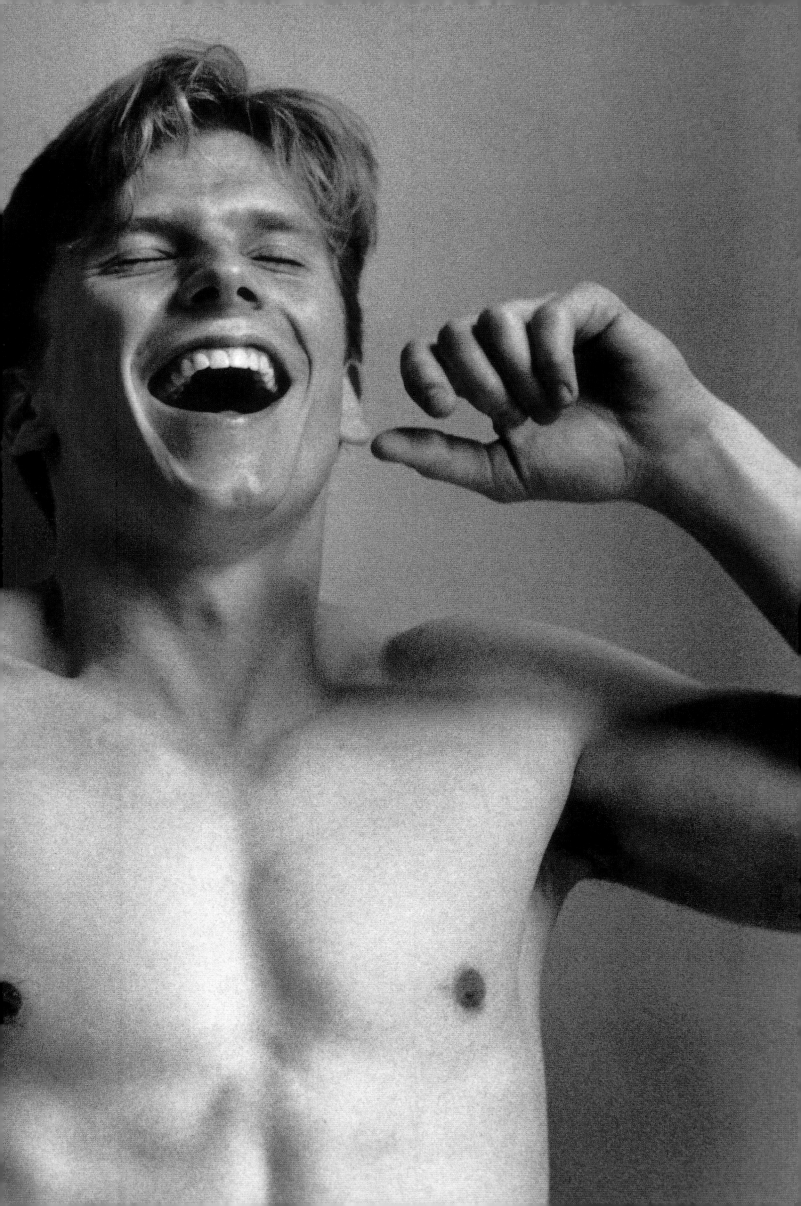

MASTICKLEBATION \ mas-ti-kel-ba-shun \ n. (1994)
The act of self-stimulation with a feather, or any amusing object,
of the funny bone which induces an uncontrollable frenzy of giggles
resulting in a climax of tears. It is judged unnatural behaviour
by most religions and especially the Saviour.
Compulsive masticklebators can be identified by
the telltale signs of hairy armpits.

Humor is seeing life askew, a silly non sequitur, *How do you do?*
a fly in the stew, *that'll be extra for the meat,* so what else is *nu?*
It makes no sense at all, an absurd play on words that teases common sense,
Your money or your wife? Humor is an excuse for not crying.
Comedians die a thousand times on stage, a brave man only once.

Woody Allen is a sage.
I heard a rumor that Hitler had no sense of humor.
When he heard a pun, funny Adolph reached for his gun.
Scrooge never laughed either. Bob Cratchit was his stooge.
I've decided what I want engraved on my tombstone:
Having a wonderful time, wish you were here.

WHAT IS HUMOR

My dreams are all so boring, they put me to sleep.
Knock, knock. Who's on Hearst? Marion Davies!
We all guffaw at comics' repertoire,
the Whoopie Goldberg cushion, shoe laces tied together,
the pratfall and slapsticks, a little seltzer in your face,
the banana peel with flying pie in the eye.
Is that a life saver in your pocket or are you just happy to see me?
A *Kick Me* sign on the tush. *Think of George W. Bush.*

A giant powder puff in the face never fails, *Make out!*
But bawdy limericks are the best, anything that rhymes with breasts.
I dreamt last night that I proposed to a girl who was wearing no clothes.
In her garden for hours, I watered her flowers, and awoke with a drip from my hose.

Blessed is he who can tell a joke when his life goes broke.
Nonsense is wonderful because it frees ideas of
restraints and amuses through contradictions.
Both Edward Lear and his nonsense rhymes were queer.
Nonsense roams the mind like a koan.
Please may I tickle your funny bone.

"Say goodnight Groucho."

WHAT IS GRIEF

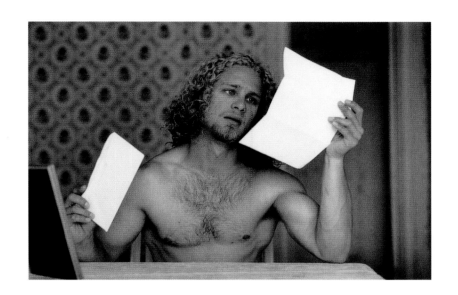

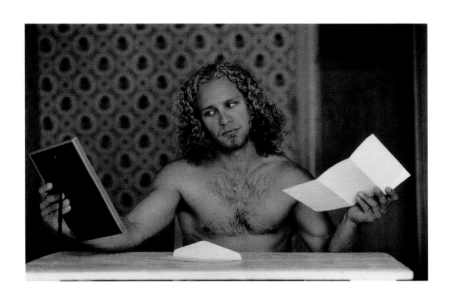

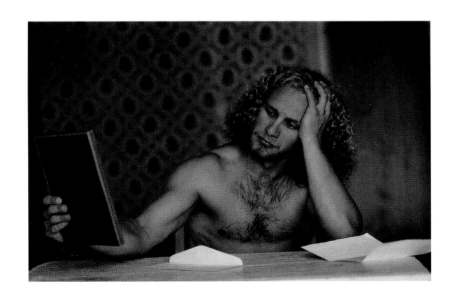

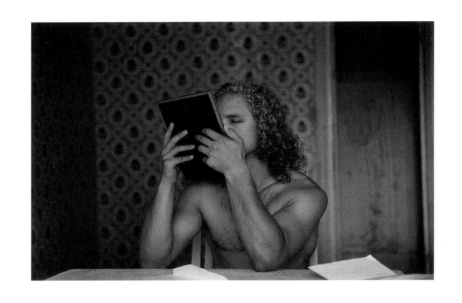

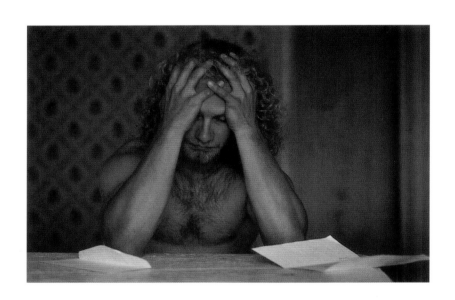

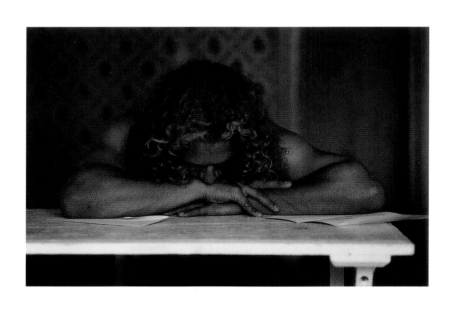

grief

is

the

unconsolable

melancholy

of

loss

Desire is a coveting need, an urgent greedy appetite
to acquire and consume to satisfaction.
Unlike love which lives to serve,
desire is self-serving and seeks its own reward.

Lust is sired by a panicked yearning that erupts in passion
and good sense and logic are dispensed.

It is a spectre in the skin that leads the hand to sin.

Desire dies when satisfied. Desire denied multiplies.

Circe and a rose do pose a lure to man and bee.
Neither can resist a honeyed kiss.
It is their destiny.

WHAT IS DESIRE

Those desired are empowered by the haunted needs of those who want.
With pleasure they concede their freedom for the hope of pleasure.

Young desire is raw and brash and ignites in a flash.
Old desire simmers slowly to delight.
Green gulps, gray sips, love lingers longer on the lips.

Desire's mystery is the impetus and tension of its quest.
When our days begin to hush and desire has lost its blush, we can see that
even desire fades in reminiscence.

I still remember even today, the way your shirt was torn,
and I glimpsed a treasured hint of your perfect form.

And with that quick glance, desire was born.

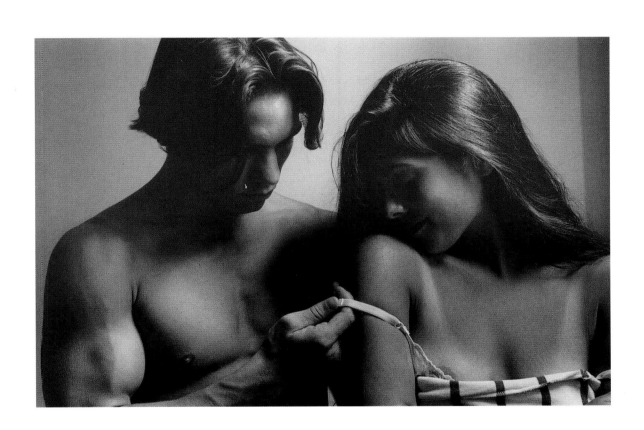

Love is a jubilant fountain
of affection one person feels for another.
It floods the heart with happiness and
overflows with joy and devotion. Like fire and air
love is a natural element, an instinct to share,
a caring laid bare, a magic potion.

Lovers fill with fascination for each other
and see in their beloved's eyes what their lives have been denied.
They know now where their futures lie.

In first love they amble into a dream landscape, and with each tryst,
time and place evaporate for these sonambulists.
Infatuation is the adolescence of love.
Romance is the fluttering of the heart when the other departs,
the blush like litmus paper.

WHAT IS LOVE

Those in love play hide and seek.
They tweak each other's cheeks and call each other's bluff.
The beloved is true North to the heart's compass.

In its impoverished dimension, unrequited love responds
to the slightest glimmers of attention with frail hope.
The most happy person is he who loves;
the saddest person is he who is not loved.
He could not tame his orphaned heart's remorse or claim himself to be
his very own, since you have roamed, and love has changed its course.

The seeds of love are sown
when the other's needs mean more than your own.

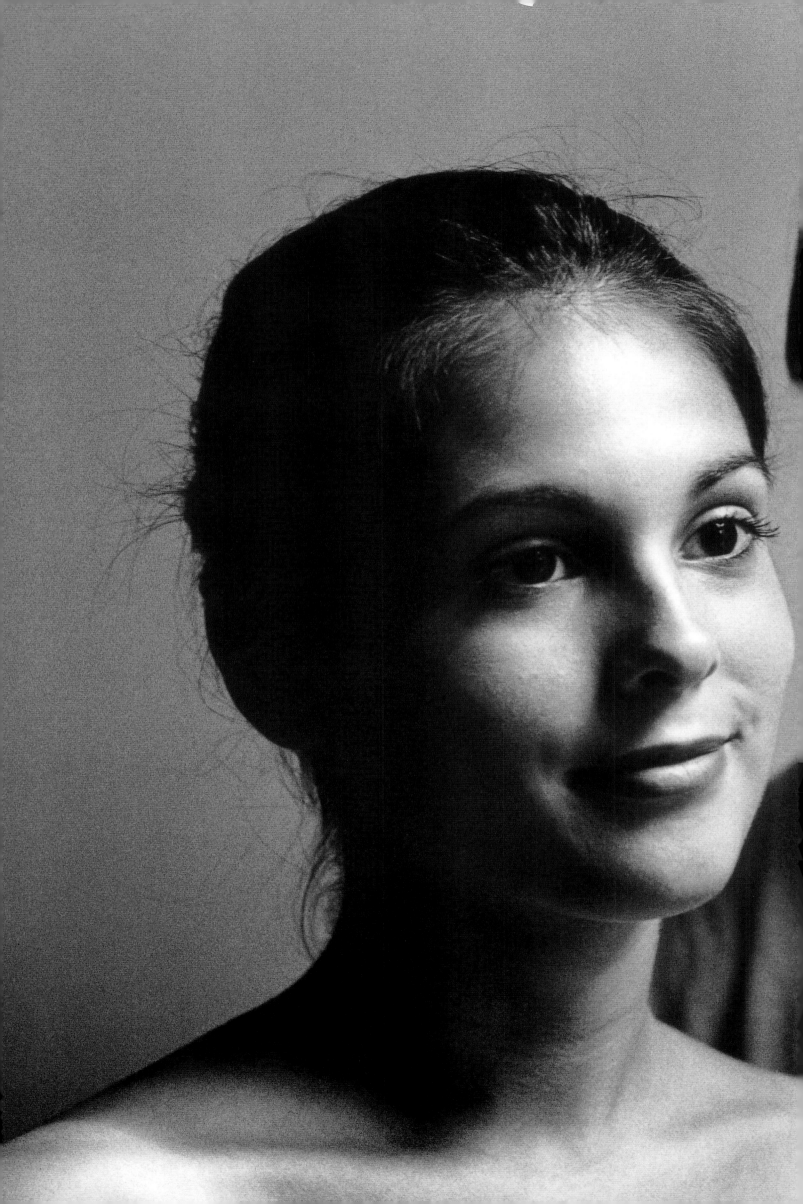

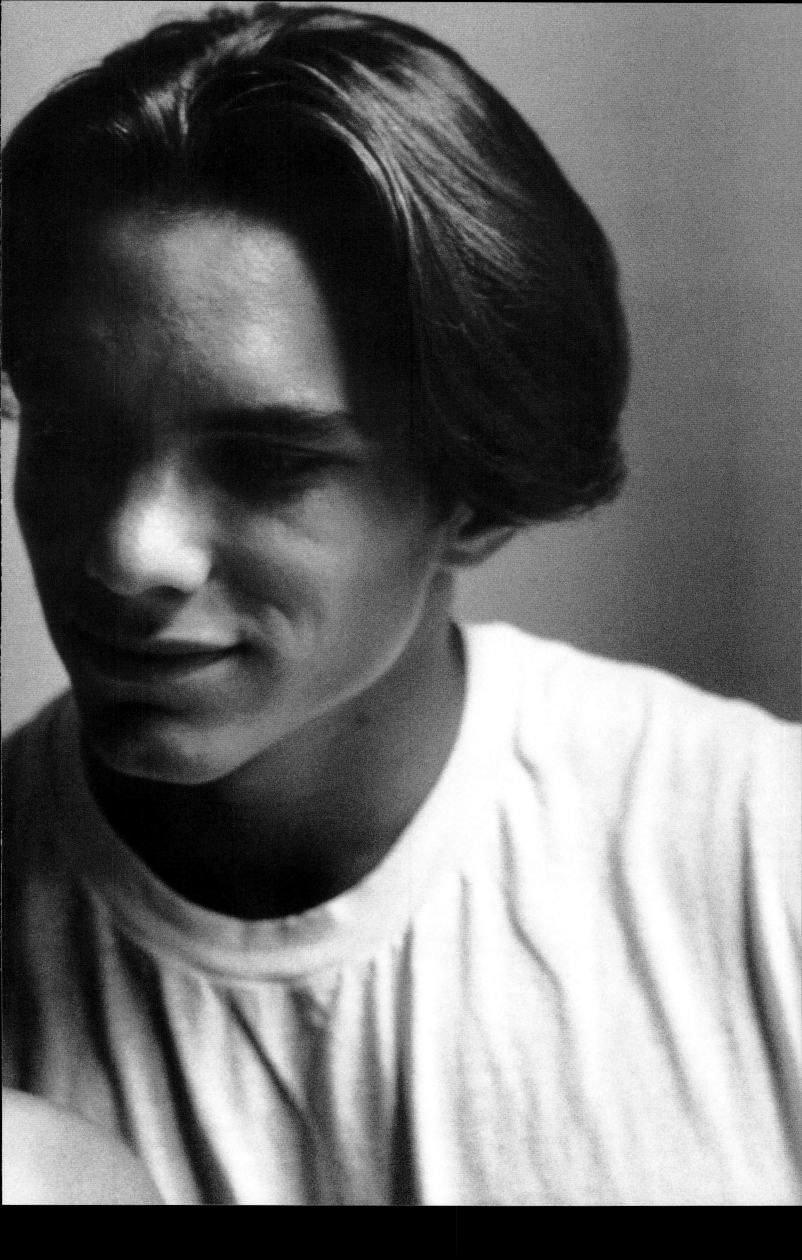

Music is a sea of sounds, whose waves wash
within the seashells of our ears and echo in their chambers,
as we drown in rhythm with what we hear.
At the center of all the circles of the universe is a vibrating tone
like a metronome that is the music of the breath of life
to us, the deaf, unknown.

Music flows forth in a rainbowed measure and ornaments our hours.
It mends the tattered heart and animates the tribal self with shrill trumpets,
timpani and gong. Now hum the hymnal songs like flowers.
It is a jazz, rock's ruckus beat, some rat-tat-tat
and stomping feet.

It trills soprano's singing towers, the violin's caress,
the tuba's bloated toot, the robin's tweet and the frolicking of a flute.
Our heart beat is a cadence.

WHAT IS MUSIC

Music is what makes heaven paradise.
There are no songs in hell, only sighs and moaning reign pell mell.
Music is the language of the divine, and we resonate in its melodic rhyme.
In a world of pain and strife, it is a kind reward that comforts us
at night, a lullaby's refrain.

Music sleeps in silence and dreams of drums
and fantastic symphonies it will play, when awake one day.
A friend of mine, who committed suicide, confided to me before he died
that his life needed background music to keep him sane.
But he never heard a sound.

How sad the soul exiled to silence.

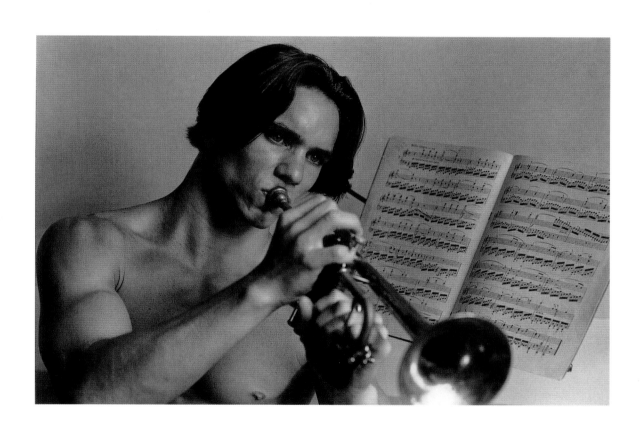

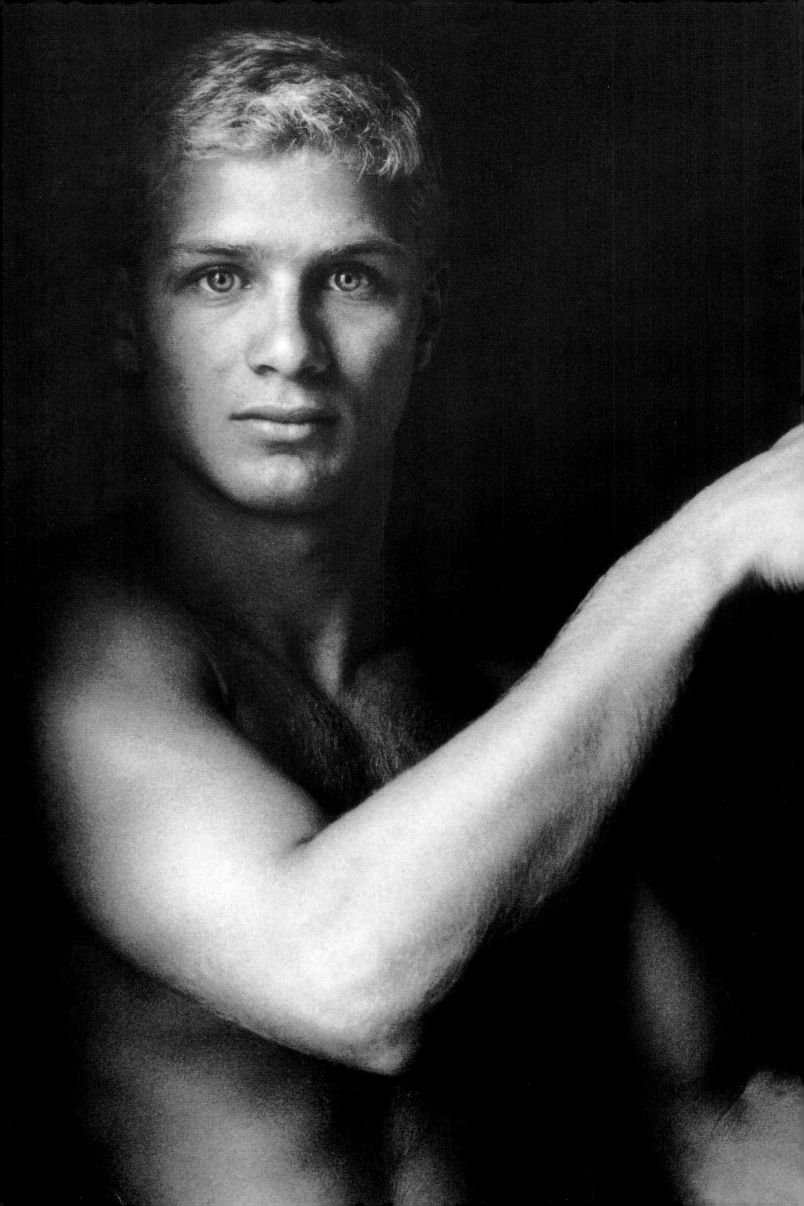

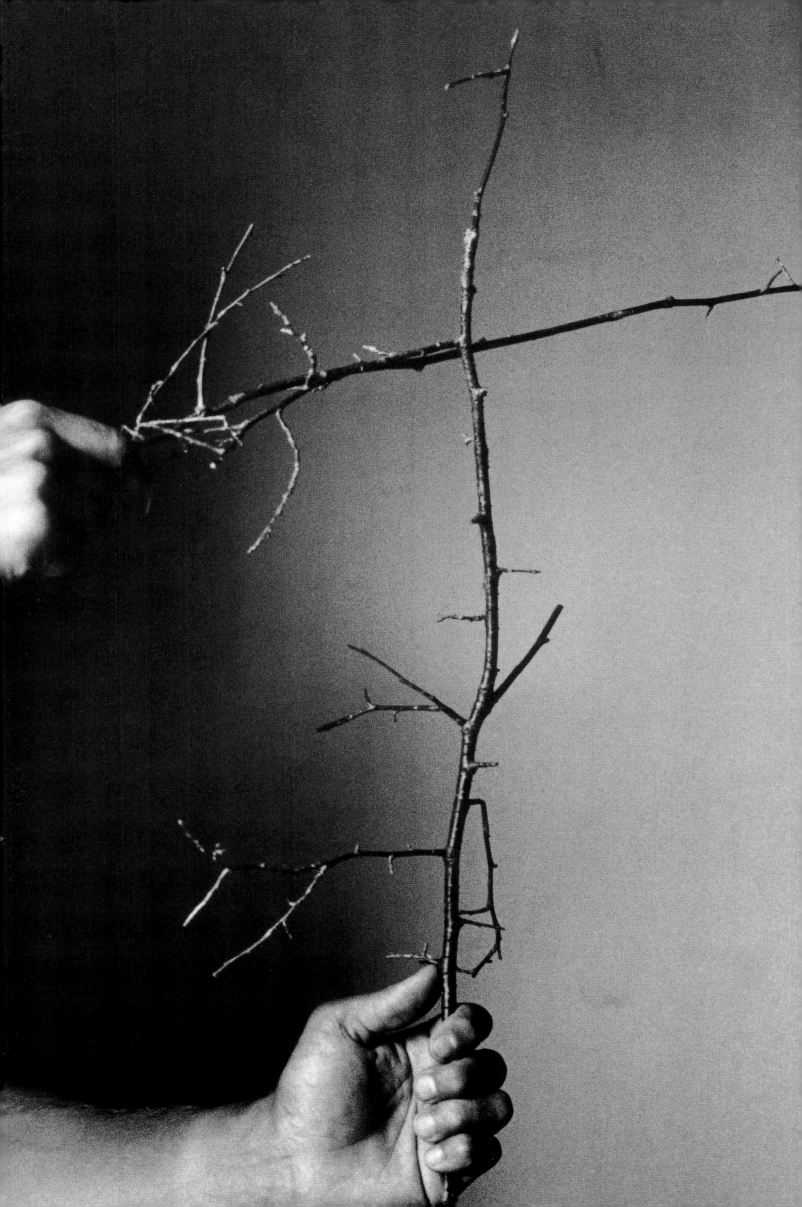

Imagine that we are dancing circus fleas, who believe
all that they can see was invented just for them in seven days
by some great Jehovah flea, whom they,
in fear of hell, must praise with meaningless clichés.

Flea brains believe all sorts of myths
from virgin births to Noah's ship.
Then there's the big bad Satan flea, who fell from Jehovah's family tree,
and only seems to lurk in the minds of those who go to church.
All Barnum flea theocracies turn guilt to gold with hypocrisy,
and salvation is sold to sinners for their generous donations.

False piety and fraud are in the air, where preachers claim to speak to God.
Flea believers' lives are spent living in their circus tents.
When one's squashed flat and dies, he never once had seen the sky.

WHAT IS GOD

As a fish cannot conceive the sea, so I cannot conceive of
that which is inconceivable to me, the all which is the all of all.

Language offers a faint description of the scope of our true condition.
The all is the light dimly viewed by our animal senses
as a sparkling speck of the most distant star in flight,
and the wreck of our body's quark collisions
spinning spirals into our mind's pitch night.

Being the all, we are fleeting conscious shadows
enthralled by our own reflections. And when the mind in time ripens
and consciousness illumes, illusions fall.
In that light shadows are erased.
Then that which cannot be defined is experienced out of time,
and we recall what we forgot, that all along,
we, in fact, were not.

Life is something from nothing, a brief light in darkness,
as seen through the distorted mirror of our senses.
Mind and matter are the same thing, alternating form
in perpetual reciprocity at dazzling velocities.
Genesis begat in a coded urge to manifestation,
and exuberant splurge of matter animating dust to consciousness.

WHAT IS LIFE

Life is a field, like gravity and electricity, vibrations of a web
that resonates in everything.
The aim of life is to sustain and recreate itself
in seeded cycles of evolutionary replication.
This mystery is a spiraling back to light,
a seamless moment's flight to its destination.

The laws of life are thus—
On nature's scale both good and evil weigh the same.
Life is not fair or just.
We are to blame for what our world became.

We are witnesses to this drama,
players in this panorama,
seeds of the divine in time.

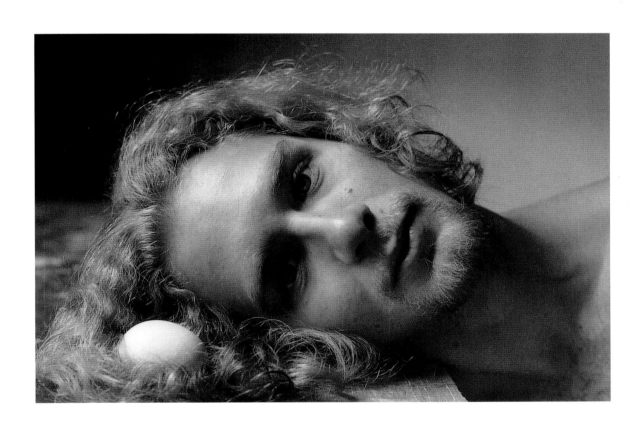

Death is not being. Not being is inconceivable
as if one born blind could imagine seeing.
Life appears and disappears like an apparition, and death
is the apparition's shadow. Death is real.
Life is unreal, an anomaly whose brief breaths of consciousness
flutter in the midst of oblivion.

The dead are at first amused by the confusing strangeness of oblivion
and then frightened by the living, who seem like ghosts to them.
"What is this peculiar dream?" "Why are they crying?" "What is this?"

You who are reading this now, why do you assume you are real
and not a phantom?

WHAT IS DEATH

Perhaps the tomb exists as a womb of metamorphosis
where life germinates to life again in constant repetition
in expanding circles of flickering vibrations.

I think therefore I am not extinct.

How foolish to fret that someone may forget
your name after you have passed away.
In the infinity of death fame lasts only for a day.

The great sadness of his father's death
was that he was not missed.

Birds do not know they will die.
They sing sweet songs and never cry.
Our joys are always compromised.
For we know what lies ahead,
The wistful beckoning of the dead.

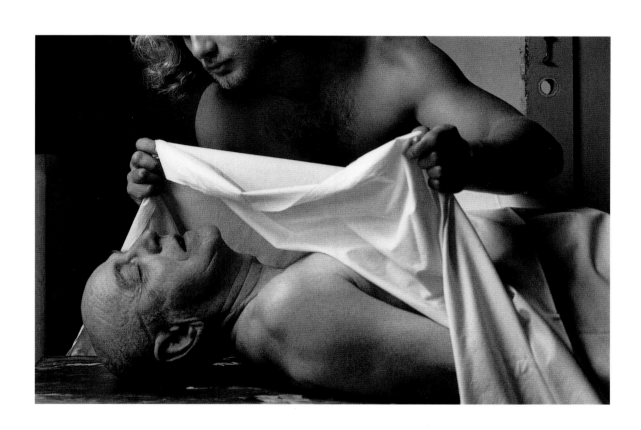

Nothing is the absence of something.

WHAT IS NOTHING

Nothing is the source of everything.

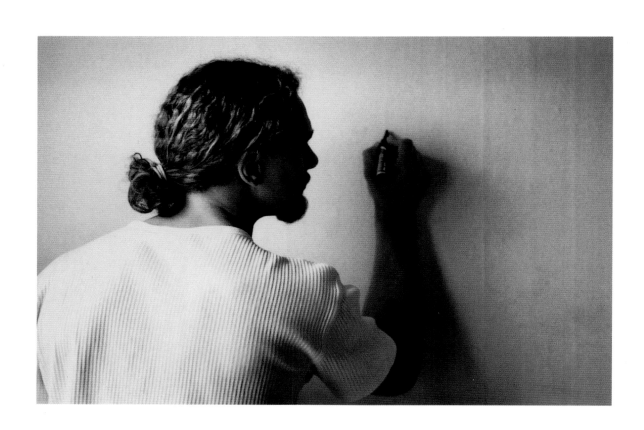

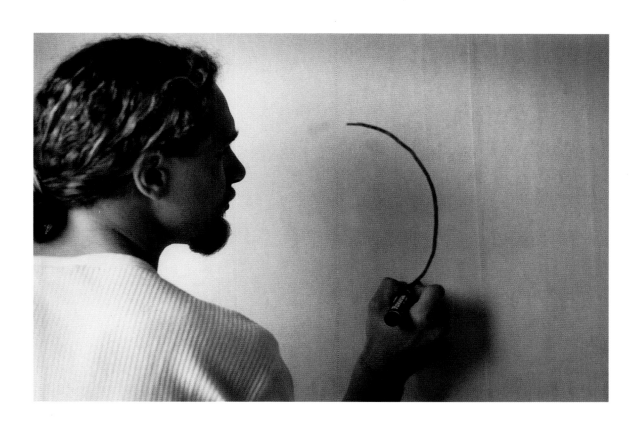

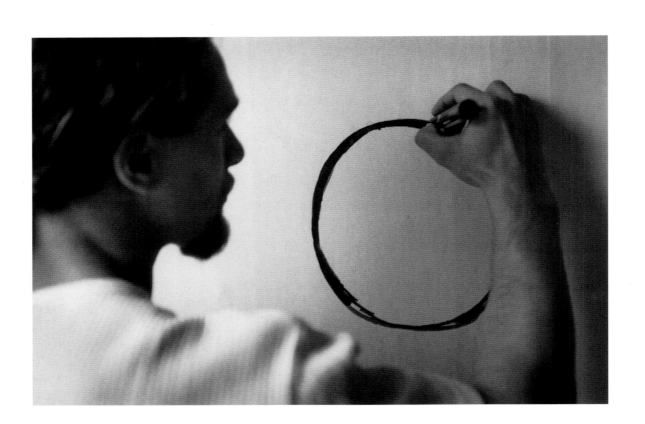

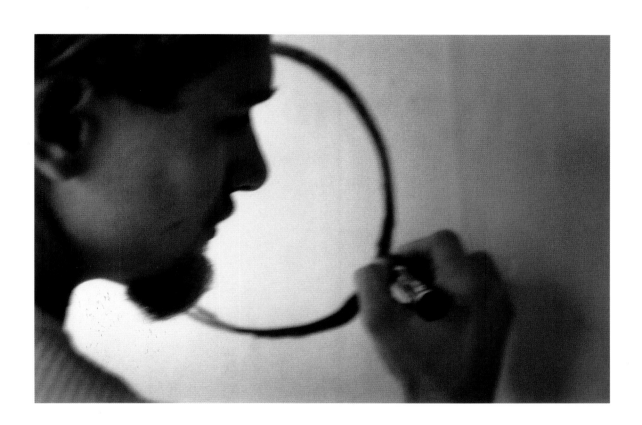

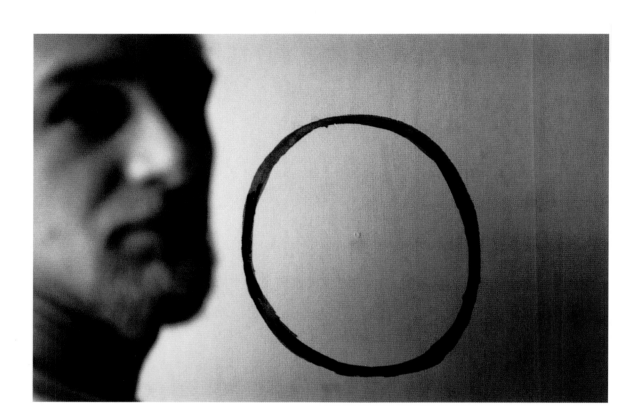

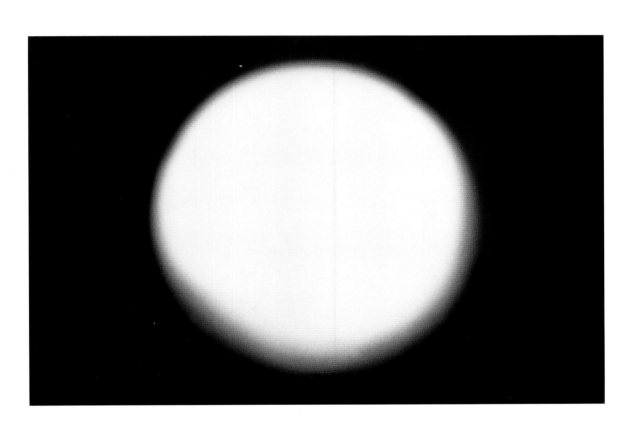

This second edition of Duane Michals:
Questions Without Answers
is limited to 1000 casebound copies.
The photographs and text
are copyright Duane Michals, 2001.
Set in the digital version of Requiem
by Eleanor Caponigro.
Designed by Jack Woody.
Printed and bound in South Korea for:

Twin Palms Publishers
Post Office Box 10229
Santa Fe, NM 87504
www.twinpalms.com

ISBN 0-944092-86-1
limited edition ISBN 0-944092-87-X

2002